REMEMBERING
THE WAY IT WAS

AT BEAUFORT, SHELDON
AND THE SEA ISLANDS

REMEMBERING
THE WAY IT WAS
AT BEAUFORT, SHELDON
AND THE SEA ISLANDS

FRAN HEYWARD MARSCHER

THE
History
PRESS

Published by The History Press
Charleston, SC 29403
www.historypress.net

Cover Image: Painting by Lynda K. Potter.
All photos courtesy of the author unless otherwise noted.

First published 2006

Manufactured in the United States

ISBN 978.1.59629.136.2

Library of Congress Cataloging-in-Publication Data

Marscher, Fran.
Remembering the way it was in Beaufort, Sheldon, and the Sea Islands /
Fran Heyward Marscher.
p. cm.
ISBN 978-1-54020-413-4 (alk. paper)
1. Beaufort County (S.C.)--Social life and customs--20th
century--Anecdotes. 2. Beaufort County (S.C.)--History, Local--Anecdotes.
3. Beaufort (S.C.)--Social life and customs--20th century--Anecdotes. 4.
Sheldon (S.C.)--Social life and customs--20th century--Anecdotes. 5. Sea
Islands--Social life and customs--20th century--Anecdotes. 6. Beaufort
(S.C.)--Biography--Anecdotes. 7. Sheldon (S.C.)--Biography--Anecdotes. 8.
Beaufort County (S.C.)--Biography--Anecdotes. 9. Sea
Islands--Biography--Anecdotes. 10. Oral history. I. Title.
F277.B3M26 2006
975.7'99043--dc22
2006014565

CONTENTS

PREFACE

No one can ever tell it all, all about the way it was, but each one can tell a bit about it. This book, pieced together from individual recollections, is part of a mosaic, the first volume in a two-part series.

I came to like and admire everyone whose story is here. The interviewees were patient and helpful and probably as truthful as their memories would allow. I think they really wanted modern-day folk to know what they could tell about the Lowcountry of long ago. Although some lived elsewhere for a few years, for all of them, northern Beaufort County was always home, the place where everybody knew their names. For their willingness to submit to my questions and to review and improve my early drafts, I am most appreciative.

There is a chapter about my husband, William Frederick "Bill" Marscher II, who introduced me to many of his childhood friends and assisted with the photos and the map. Through this project, I have come to love the region he loved as a barefoot boy.

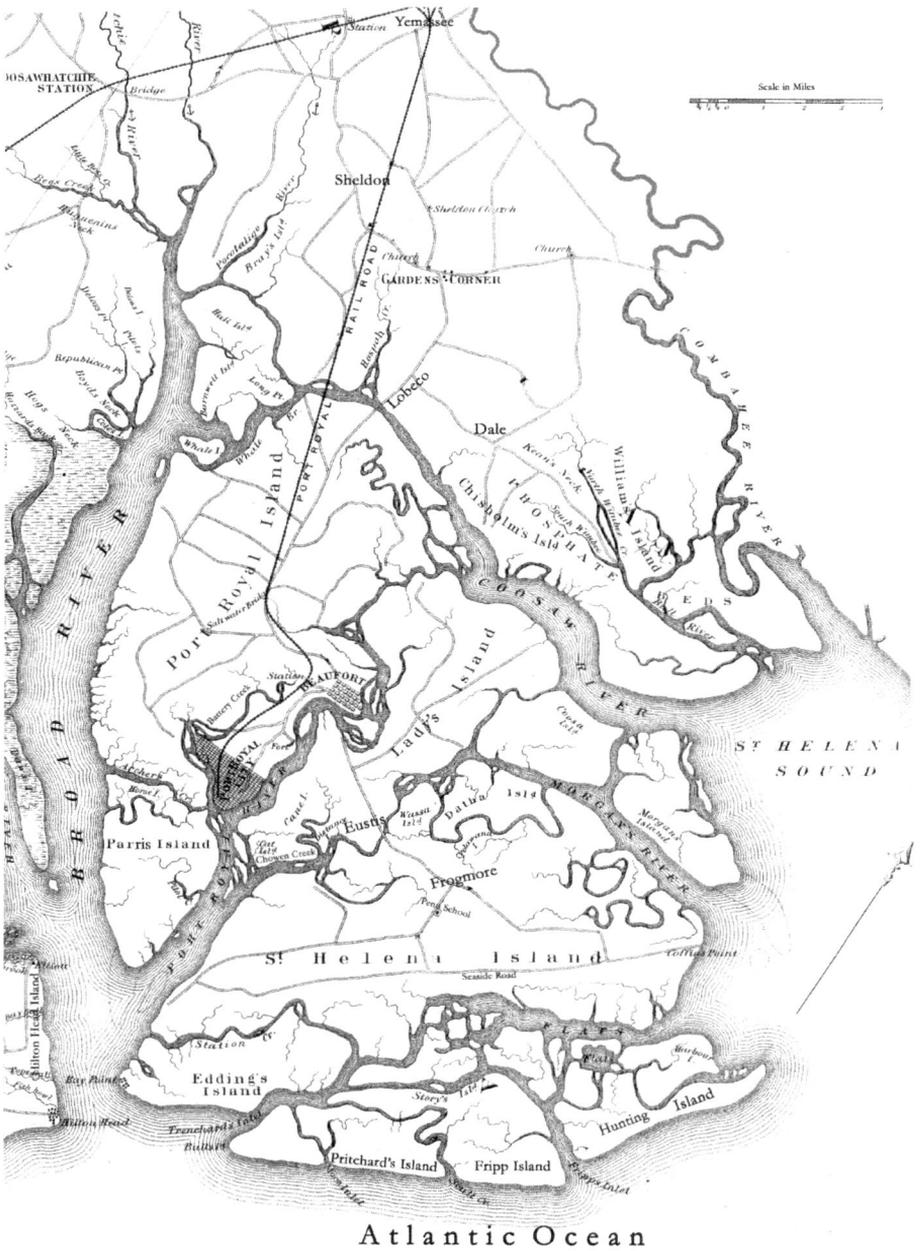

Section of the South Carolina Lowcountry where the storytellers lived. *Courtesy of the South Carolina Land Improvement Company, 1877.*

INTRODUCTION

A charmed corner of South Carolina it was in the early twentieth century—Beaufort the town flanked on the east by the water-laced Sea Islands and on the west by rural fields, woods and small family compounds. Compared to Bluffton, Hilton Head Island and Daufuskie in those years, Beaufort County north of the Broad River was a whir of activity; in addition to the seafood industry, it had a military base and a courthouse, serious farming, a working railroad.

Compared to much of South Carolina, it had a diverse mix of folk: a huge predominance of Gullahs, a few white remnants of the ruined plantation society, a few white entrepreneurs. During that period, it almost perfectly illustrated the huge migration of blacks to northern cities to look for opportunities unavailable locally. Beaufort County's 1900 population of 35,000—of which 32,000 were black—by 1920 had fallen to 22,000, of which 17,000 were black. In 1940, the population still was 22,000, of which 15,000 were black.

Peninsulas and islands—hundreds, ranging in size from thousands of acres to less than one acre—made up the county's landscape. Between the sections of relatively dry ground, the tidal creeks rose and fell six to nine feet twice a day. The scenery changed minute by minute.

Quail whistled their familiar "bob white" from the underbrush. Porches were used in mornings for shelling butter beans and in late afternoons

for resting and swapping the news of the day. In summer, the windows of both the huge antebellum houses and the small cabin homes were opened to catch whatever breezes wafted by. In winter, gray chimney smoke heralded evidence of the warmth inside. So quiet were the neighborhoods everywhere that the crack of a bat against a baseball could be heard for a quarter of a mile.

The region had a range of scents. A walk down a city street could lead one to sweet Confederate jasmine or to an ammonia-scented outhouse. A walk down a sandy road could lead one to a magnolia tree of heady blossoms or to a breathtaking hog pen. Tidal marsh and mud emitted a pungent fragrance. Collards cooking on the stove emitted something equally distinctive.

Everybody lived close to the land and close to the water. Whether working in the Peoples Bank or the Blue Channel crab meat factory, whether hoeing in the fields or looking for oysters for supper, whether waiting for a vendor with fresh flounder or planning an outing on the Owanee houseboat, Beaufort County folk knew when the tide was ebbing and when it was flooding. Tidal cycles mattered almost as much as day and night, almost as much as seasons. St. Helena folk especially used the tide to help them travel the creeks.

The old-time residents I interviewed—men and women, blacks and whites—had to sit still for a bit and furrow their brows to think back to the days of their youth. "What one sees depends on where one stands" was especially true in this racially divided community. To a person, though, it was with joy that they told of the past as best they could recall it. They revealed hardships and tragedies, scarcity of cash and early deaths, but it was the good times they remembered best of all: "Praise to the Lord" in St. Helena's Episcopal Church, wheelbarrow vendors selling shrimp and okra, baptisms in the creek.

The place will never again be the same as it was the way these characters lived in it many decades ago. For you, dear reader, imagine yourself in a swing on the porch while these people rock back and forth and transport you back to another time and place. Listen to the wind in the palmettos.

PERSPECTIVE ON THE BIRTH YEARS

1909–1919

In the twentieth century's first couple of decades, northern Beaufort County enjoyed a unique remoteness. One could travel by railroad, sailboat, rowboat, ferry or by one of the steamers hauling passengers and cargo on their regular runs serving Savannah, Beaufort and Charleston. Or one could take the train, the Black and Dusty, to Yemassee to meet the Charleston and Western Carolina Railroad and on to Augusta. In 1907 the swing bridge across the Whale Branch River was completed. However, no vehicle bridges linked Port Royal Island directly to either southern Beaufort County or to Lady's Island, St. Helena and the islands beyond.

By then, vegetable crops had replaced all but a few rows of cotton as important exports. The L.P. Maggioni and Co.'s big oyster-canning factory paid a bit of cash for those who picked and shucked. In 1915 the U.S. Marine Corps began training recruits on Parris Island. Some folk had jobs in the courthouse and the law offices, in the schools, on the waterfront or for the general stores or the railroad or the bank. The rhythm of the workday required long breaks for the midday meal, a meal called dinner. Rice and gravy were almost always on the menu.

Elsewhere, World War I erupted during that period. Richard Strauss's opera "Der Rosenkavalier" opened in Germany. Four women arrested for picketing the White House on behalf of women's suffrage were sentenced to six months in jail.

And yet, many decades beyond the prosperous plantation era and the devastating Civil War that ended it, time stood almost still in the South Carolina Lowcountry.

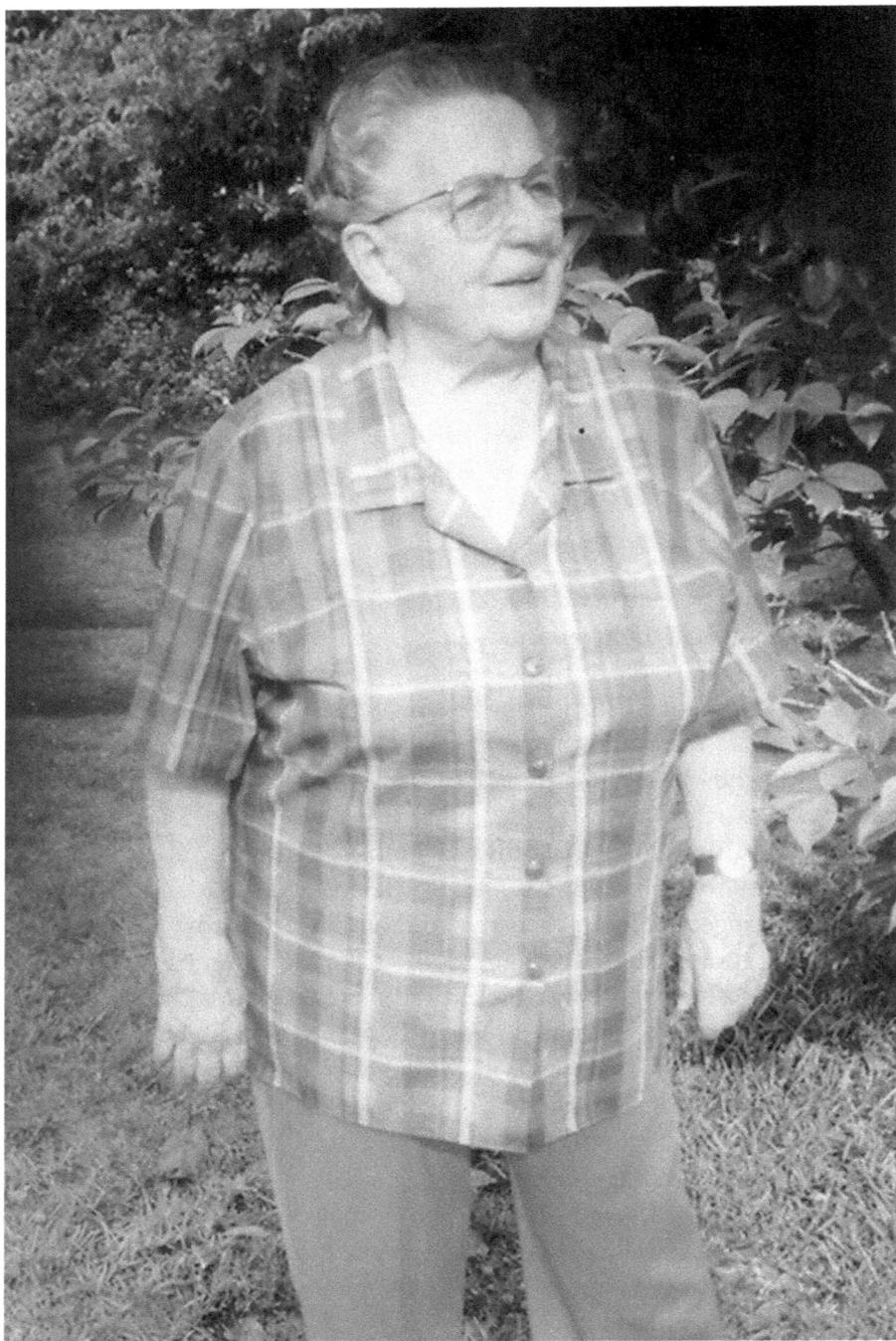

Grace White.

A LADY OF VISION

Grace White
born 1910

Law clients continued to be scarce and fees small. Sometimes she took her pay in turnips, fish and scrawny chickens.

Despite failing eyesight, Grace White could see Beaufort's past clearly.

As the first Beaufort girl to go into law, she could focus laser-like on incidents showing deeply ingrained and long-running bias. Fortunately, she could focus even more precisely on examples of respect and trust and affection that filled her life as a professional and as a volunteer in the community during more than half of the twentieth century. She practiced law for more than sixty years—and still did not consider herself completely retired at the age of eighty-nine.

In 1909, Grace White's parents rented the Secession House on Craven Street and hired the Secession House cook, all for twenty dollars a month. By the time Grace was born in Marine officers' quarters in Washington, D.C., in 1910, her mother and father had already come to love the Beaufort people, the Beaufort spirit, the Beaufort scenery, even the Beaufort marsh smell and the Beaufort humidity. By 1917, after tours of Marine duty elsewhere, the family was living for a second time in the South Carolina Lowcountry, this time on Parris Island.

Along with other Marine families' children living on Parris Island, little Grace caught an open-air thirty-foot navy launch called a "motor kicker" morning and afternoon to attend school. The wind in their faces, the boys

and girls watched feeding dolphins and diving terns along their way. The bridge to Parris Island was not finished until the year Grace graduated from Beaufort High School, in 1928.

This was the era in which black fishermen walked the streets of the town calling, "Swimps [fresh shrimp] going by." Okra, butter beans and other produce and seafood were offered similarly, the merchandise hauled in wheelbarrows and in baskets on the merchants' heads. It was the era when Beaufort residents caught a boat to Parris Island, the "movie boat," in order to get to the only movie theatre between Savannah and Charleston. The "movie boat" that crossed Battery Creek took them to see *Birth of a Nation* and *All Quiet on the Western Front*, films that were a mere afternoon's entertainment at the time but that became classics. Those were the days when children romped all summer in the "bathhouse," a facility for river swimming at the end of the dock in front of the Sea Island Hotel on Beaufort's Bay Street.

GOING FOR THE BAR

After high school graduation, Grace studied pre-law and law at George Washington University, graduating in 1934 as the only woman in a law school class of men who were dumbfounded that she was among them. She passed the bar exams of the District of Columbia and the state of South Carolina and took the oaths as required. As other law candidates did at the time, she swore she would not engage in dueling. Feeling like something of a "big shot," she returned to "beautiful Beaufort by the sea, twenty-six miles from Yemassee," hopeful and determined to make a living in her hometown.

For a long time, she could not pry or coax her way into the legal community. In February 1937, by offering to keep open the office of a lawyer-legislator, Bill Elliott, when he was legislating in Columbia, Grace managed at last to get herself a desk, a window with a view overlooking Bay Street and a door with her name on it. Their space was above Cohens' grocery store. Law clients continued to be scarce and fees small. Sometimes Grace took her pay in turnips, fish and scrawny chickens. She notes that none of that would buy shoes.

Eventually, Grace built a practice around legal work that the other seven lawyers in the county did not want. In 1939, Floyd the butcher needed help with tax records and reports, which she provided. She started handling simple tax returns, payroll records, estate issues—almost anything that involved clients' legal and monetary obligations to the government. Within a few

years, she had more than 150 steady tax-law clients. Gradually, she also built up a practice of land-title work, especially in the tedious field of clearing "heirs' property," property handed down from generation to generation in accordance with state probate law and in the absence of wills.

VARIED VOLUNTEER SERVICE

In addition to practicing law, Grace earned her place in what has been called the "greatest generation."

Before and during World War II, the selective service required all young men eligible for the military draft to fill out questionnaires and asked lawyers in every community in the country to volunteer to help them handle the paperwork, a forty-five-minute task. Guess which lawyer in Beaufort had the most young men come into the office with the questionnaires folded up in their hip pockets?

A second war-time effort involved the "watchtower," a forty-five-foot wooden structure used for spotting, reporting and recording all aircraft in the area, the forerunner of radar equipment, which had been invented but which had not been refined and had not been installed in the nation's vulnerable coastal communities. Watchtower observers were recruited and organized for two-hour stints at a time, the idea being to make sure no enemy could deliver a surprise attack along the nation's shoreline, day or night.

Grace spent two hours every week in Beaufort's tower on Pigeon Point. She especially recalled one cold February morning when the wind from a northeaster shook the tower so fiercely she almost fell out of the old Chevrolet seat recycled as a sofa on the platform at the top.

In case the Germans or Japanese launched a submarine invasion up the Beaufort River, Grace served also as chairman of the Auxiliary Ambulance Corps, an essential arm of the Red Cross Motor Corps. Her fleet of "ambulances" consisted of the pickups owned by the merchants on Bay Street.

Along with the other war-related tasks, Grace volunteered for the tedious, somewhat thankless duty of serving on the local ration board's complaint committee.

At the age of ninety-five Grace White still lived alone in the home on Carteret Street that her father remodeled in 1937. A victim of macular degeneration, she had gradually learned to compensate for the loss of vision. She organized her daily life as effectively as she organized her legal work in the past. Friends provided transportation and a few other services,

including turning the pages on the calendar she could not see. By using a telesensory visual aid machine and moving a tray under it right and left and backward and forward, she was still able late in life to read and write and thus take care of her personal business as well as provide an essential service to St. Helena's Episcopal Church. Every Friday, Grace would telephone the church's acolytes, ushers and lay ministers to tell them that they were on the church's schedule for service the following Sunday. The conversations were something she enjoyed—one more way to connect with the people in her community.

Clearly, at the beginning of the twenty-first century, despite her weakened eyesight, Grace White could see Beaufort's past quite well and could see the present well enough to continue being a part of it. As to the future, she saw that only dimly. In that respect, she was, of course, like the rest of us.

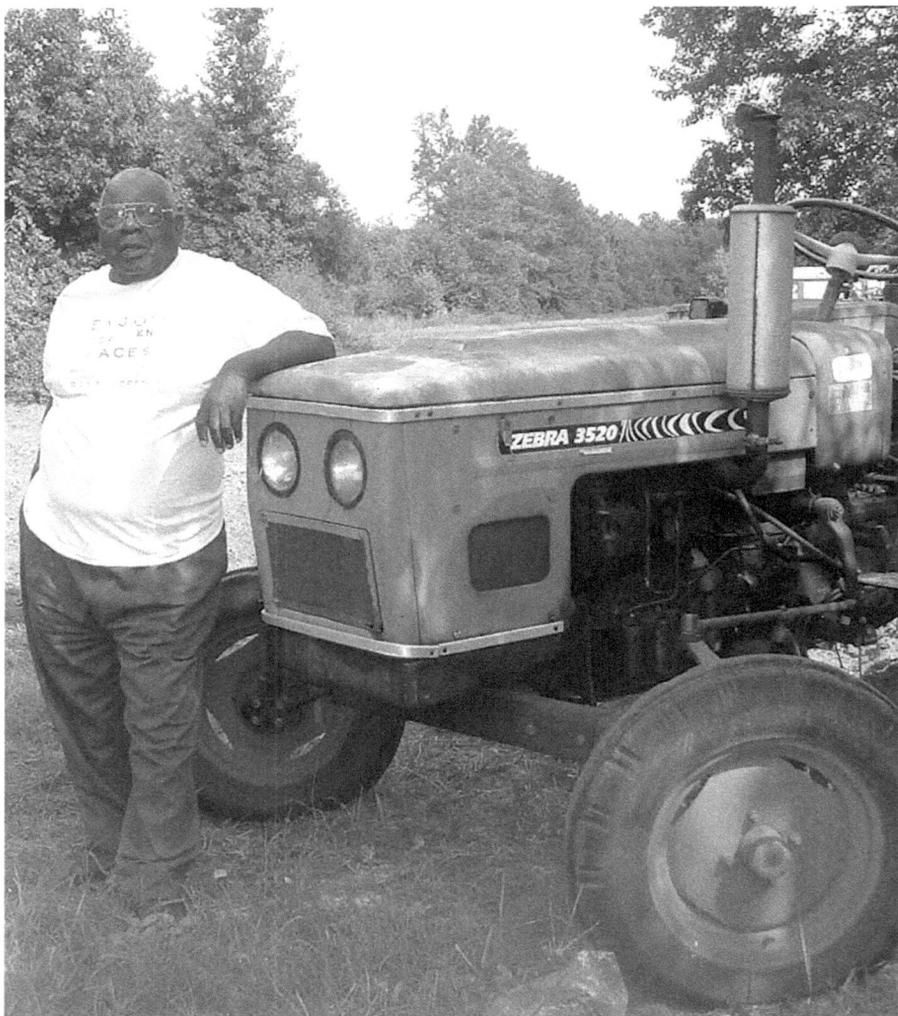

Jackson Brown and tractor.

A STAR IN
THE GAME OF LIFE

Jackson Brown
born 1917

At the age of nineteen, Jackson started "going one place and another to try to do better."

Jackson Brown was only a little fellow when he started swinging a bat and tossing a ball. He was not much bigger when he found out he could pitch that ball over the home plate. Soon he was playing whatever position needed playing for the Dale Tigers. When he was the starting pitcher, he said, they hardly ever lost a game. When another pitcher started and the Tigers found themselves down five or six runs, he would take over the mound, and in his memory more than half a century later, he would almost always pull out the win for his team.

"The way to win has always been to not let them hit," he said. Drafted into the army during World War II, Jackson was asked about his baseball skills. Somebody wanted to know what position he played. "There are nine positions, so I play nine positions," he answered.

Early in the twentieth century, every little community in the region had its baseball team. Baseball demanded only modest equipment. Fields that could be converted into baseball diamonds were everywhere.

"If you're from around here, you know that black folks in those days didn't go to school but three months a year," Jackson said. I nodded yes. "Well, we played baseball the rest of the time, every chance we got. When

we weren't playing games, we practiced throwin' and catchin' and battin'. We loved that baseball."

Swatting sand gnats that might have interfered with the game, Jackson played baseball until he was in his forties. He taught his sons to play. One son pitched Battery Creek High School to a state championship. One played for the Kansas City Royals. Unfortunately, Jackson said, he "missed a clause" in that professional contract that cost his son a career in baseball. "I thought he was signin' up to be a center fielder. They had him going in as a pitcher. Then he injured his arm. I could hardly bear it." Jackson felt terrible. He understood, however, that "the people in that [baseball] business study that stuff. I was so happy for him to have a contract, I didn't really read that contract carefully enough."

He also taught his grandsons to play baseball. The day I interviewed Jackson Brown, a young grandson waited anxiously to be driven by his grandfather in his blue pickup truck to baseball practice. Jackson liked the Dodgers and the Cubs, and he tried never to miss one of their games on TV.

"Fishin' with my pastor"

Like baseball, fishing was something Jackson started doing as a child. Unlike playing baseball, though, fishing was something he could keep doing well into his ninth decade. "If I hadn't had this appointment with you to talk, I'd have been fishin' with my pastor," he told me jovially. "I love that fishin'."

Jackson fished "for whatever was bitin'" in Whale Branch. For bait, he used dead shrimp sometimes, live shrimp sometimes. "But when the trout's bitin', you can catch 'em on a white rag," he said.

Out of Jackson's baseball years, he faced many a curveball, many a fastball. As for his fishing excursions, he faced a few days when the fish would not bite dead shrimp, live shrimp or white rags. By some measures, he faced huge disadvantages all of his life. He didn't let them get him down.

Childhood on the farm

The next to last child in a family of nine children, born in 1917, Jackson grew up in the Dale neighborhood called Coosaw Mine, site of the big river-phosphate mining operation demolished in the 1893 hurricane. By the time Jackson was born, the area was known not for its phosphate but for its tomatoes, corn, potatoes, lettuce, collards—all the truck crops

important throughout the Lowcountry in those days.

"My father passed when I was very small. So there was just my mother," Jackson said. "She worked for other people on their farms for two dollars a week. I was still quite young when I took on the job of water boy, pumpin' water with a hand pump and haulin' it in a bucket to the workers in the fields. Sometimes I would tote that water half a mile. I cleaned the ditches. I earned twenty cents a day.

"There was one sto' in Dale, and it would let you have a little credit. But if you ran up a credit of ten dollars, oh, boy, it would take a long time to pay that off."

At the age of nineteen, Jackson started "going one place and another to try to do better," he said. He worked for a few months for the railroad, in the "floatin' gang," a crew that would be sent all around on errands of maintenance and crisis management. He went to Savannah, couldn't find a job, went to Clewiston, Florida, where he found work in the sugar cane fields. "That was a terrible job. Those sharp stalks will cut you. It's dirty and nasty, and I knew soon after gettin' into that cane, I had to get out of there," he said.

MILITARY SERVICE ABROAD

In 1940, Jackson got a job in construction on Parris Island. In 1942, he was drafted and sent to North Africa, Sicily and Italy, spending most of his time in the combat zone. What an experience. The military still was not integrated, but Jackson said he "made out pretty good under the circumstances." Always up for a challenge, strong, feisty Jackson resisted once going to an air raid shelter when told to do so. "I told the colonel that if the Germans wanted me they could come try to get me. That wasn't too smart. I ended up going into the shelter like I was told." Out of the military experience, Jackson said he learned to be responsible and to cooperate.

After the war, Jackson came back to Dale and landed the job that became his life's work: in the civil service, driving a truck on Parris Island. "It didn't pay too well," he said. It did mean a steady paycheck, though, and it was better than harvesting sugar cane. He stayed there until retiring in 1973.

Jackson and Arizona Brown raised five boys and two girls in Dale. Early in the twenty-first century, Jackson was proud of all of them. Of the seven, four had earned college degrees. "And if the other three would go after those degrees, I'd go to work to help pay the cost," he said. By the twenty-first century, one of his children lived in Savannah, one in New

York and the rest almost within shouting distance of Jackson's house on Community Center Road just off Keans Neck Road in Dale.

At the age of eighty-eight, Jackson planted collards and rutabagas in the fall; drove his grandson to baseball practice; watched baseball on TV; went fishing most Thursdays, Fridays and Saturdays; attended Mount Carmel Baptist Church on Sundays. Along his life's journey, he had discovered an ability to convert curveballs into base hits. By that time, from some points of view, he had knocked many of life's fastballs clear over the fence.

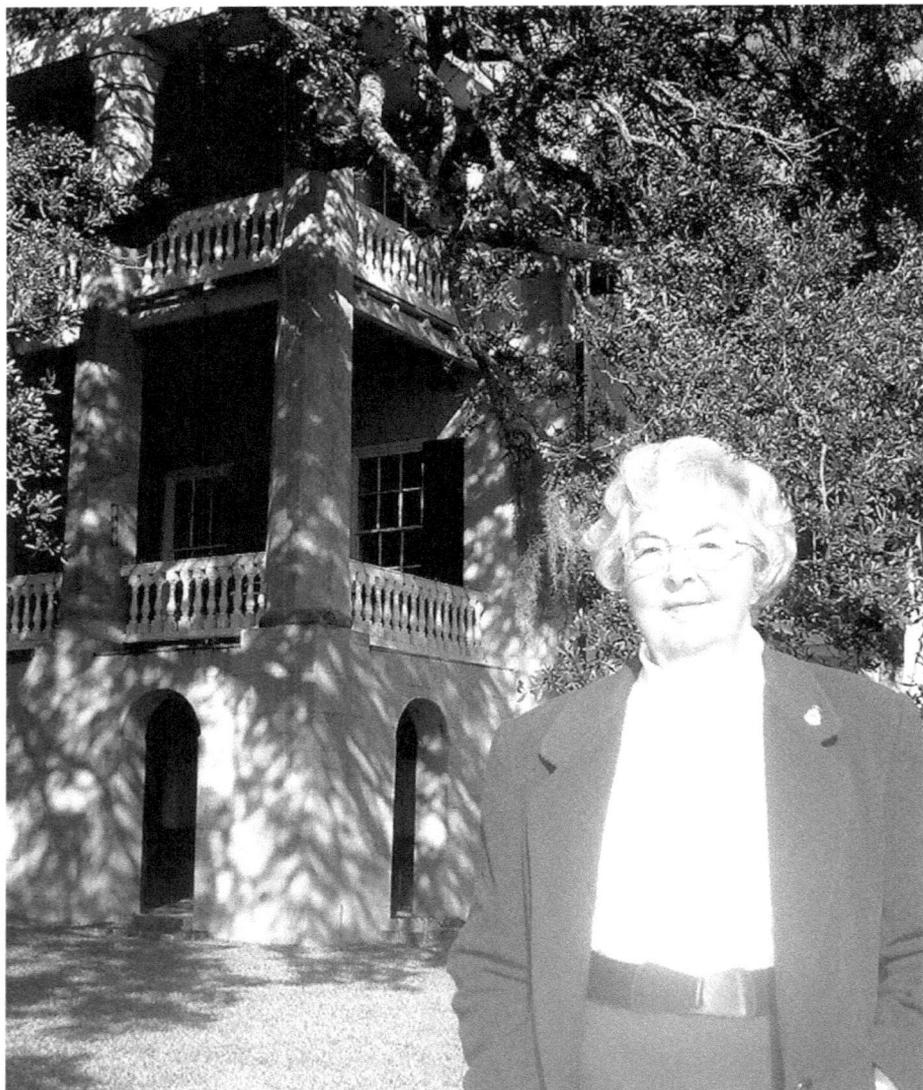

Dee Hryharrow in front of castle.

Memory goes back to a castle and a rowboat

Ruby Ellis "Dee" Hryharrow
born 1918

She painted dozens of little shiny faces until she found herself painting the grandchildren of children she had painted years before.

Early in the twenty-first century, old Beaufortonians watched in awe as their hometown piled up accolades from the national media: most livable small city, most romantic small city, most polite, most attractive, most everything. Ruby Ellis "Dee" Hryharrow, who had been selling real estate in and around Beaufort for thirty years, couldn't have been happier.

By then, she was the listing agent for what may have been the most expensive residence in the city: an antebellum multi-columned house on a full city block overlooking the Beaufort River—six bedrooms, eight fireplaces and a double-wide staircase gracing the central hall. Locals called it "The Castle." Its asking price was $4.4 million.

Smiling, she said, "We've had quite a few houses sell for more than $1 million on The Point, but I'm pretty sure that price would be a record."

By then The Castle, circa 1850, had occupied an important place in Dee's heart for most of her life. When Dee was a child, her Aunt Lily Danner lived in The Castle, and Dee's family lived across the street. When Aunt Lily died, Dee's parents bought The Castle and made it their home. By that time Dee was in college, but when Dee's husband was in

military service and she was rearing and bearing children later in her life, she lived briefly with her parents in The Castle.

Then her parents died and left The Castle to Dee and her two brothers. Dee's brothers were living elsewhere. The house reportedly had a ghostly French dwarf living in it. Dee "wanted no part" of owning and living in that huge house. It went on the market again. A Californian who appeared to be wealthy bought The Castle sight unseen as a birthday gift for his wife. Unfortunately, his desire outstripped his bank account. The Danner family estate put the house back on the market and sold it to Bill Rauch, the New Yorker who moved to Beaufort and became mayor. Rauch settled into The Castle with his wife and children for a few years before putting it on the market again in 2005, with Dee as the listing agent.

A LESS GLAMOROUS BEAUFORT

Looking back to the Beaufort of her childhood, Dee said she lived in a "rundown town where everybody was poor." Not much was going on to stir the economy. The neighborhoods showed signs of wear and tear—paint peeling off the walls, roofs and sills sagging. Storms, neglect and in some cases termites and rot had attacked the grand old planters' homes, some of them dating to the colonial period, many dating before the Civil War.

"We didn't realize at the time Beaufort was falling down around us. Thank goodness a few Yankees with money came later and started buying up houses and fixing them up, or I don't know what would have happened to us," Dee said.

Dee's family's ties to the South Carolina Lowcountry go back to the late 1800s. Her grandmother had moved to Beaufort from Vermont as a little girl. Her grandfather, whose family had come out of Pennsylvania to Charleston, moved here in the 1890s and opened a department store with his brother. When Dee's grandfather died, he left the Wallace & Danner department store to Dee's father. Well into the twentieth century, Wallace & Danner supplied the local folk with clothing, shoes and sundries.

THE CYCLE OF CHILDHOOD

Born in Beaufort in 1918, the first of Howard and Ruby Danner's three children, Dee, like her playmates, lived a water-oriented life. She spent many

a summer day swimming on the sandy beach off The Point and bogging with her friends back and forth to the sandbar. She looked forward three times a week to the "Savannah boat," a passenger-and-cargo steamer traveling on a regular schedule linking isolated Beaufort with Savannah, Hilton Head Island, Bluffton and Daufuskie. She remembered Beaufort folk taking the Savannah boat to the eye doctor, among other errands. Until the Lady's Island Bridge was built in 1927, the family had to catch a steamer ferry at the foot of Carteret Street to visit relatives in Frogmore on St. Helena Island.

After graduating from Beaufort High School with the third highest grades in a class of thirty-two, Dee got a scholarship to the University of Richmond, where she took advantage of a collateral opportunity. She had never liked her name, Ruby Ellis. She thought the name "Dee" would be cute. So she told her new college friends her name was "Dee," and "Dee" she was called ever after.

When Dee graduated from college with a degree in English literature in 1939 (after majoring in "boys," in her words) her father lamented that "a hunk of money had gone down the drain." So he sent her to New York City to live with a cousin and study art at the Pratt Institute. In the early '40s, with an English degree and an art diploma, Dee got a job selling ladies' apparel in a specialty shop on Fifth Avenue, Lanz of Salzburg.

The next year, Dee married John Hryharrow, a college boyfriend from Connecticut, and spent three years living on Eighth Street in Greenwich Village, with John commuting to Jersey City to work for Continental Can. For Dee, the young girl from "rundown," quiet, predictable Beaufort, life in New York was lovely. Next, Dee suffered what she called the "most miserable" time ever in her life, with John on a year's assignment with Continental Can in Wilkes-Barre, Pennsylvania. Walking down the street pushing a baby carriage, the young woman who had always made friends easily would try to strike up a conversation with another baby-strolling woman. "They wouldn't talk to me," she said. "I did not make one friend there. I was so lonesome I could die."

After another brief sojourn elsewhere, John decided they really ought to move to Beaufort, Dee's hometown, and Dee was delighted. Dee's father gave John a job in the department store. When Dee's father died, he left Wallace & Danner to John. That late nineteenth-century investment by Dee's grandfather had paid off for the family.

In the '70s, though, when Kmart and the shopping centers began to pull customers away from Bay Street, when the current wave of tourists

had not yet discovered Beaufort, the once prosperous Wallace & Danner department store started losing money. By the time Dee and John Hryharrow sold the property, they were glad to get rid of it.

ART AND REAL ESTATE

Through the middle of the twentieth century John and Dee reared their two sons and a daughter in a big house in Hundred Pines off Hermitage Road. As the children got older, Dee more and more often picked up her watercolors, her pastels and her brush. When she began painting children's portraits, she found herself running an assembly line. Although she would have preferred painting flowers, the portrait business paid well. She painted dozens of little shiny faces until she found herself painting the grandchildren of children she had painted years before. After that, having a low tolerance for boredom, she backed away from portraits.

By that point, Dee had identified selling real estate as her next move. At the age of fifty-seven she got her license, negotiated for some listings and was off and running. "In real estate, you meet all kinds of people and you find out almost everything going on. I love it," she said. In her mind, the best listing was "land," on which commissions were 10 percent, instead of residential and commercial property, on which commissions were 6 percent. "Besides, with land you don't have to worry about termites."

Years after what she called "a lot of good experience," Dee moved slowly but moved steadily and kept moving. John had died in 1990. She lived alone in a house she had built about a dozen years earlier at the corner of King and New streets in the Beaufort Historic District. She didn't work as hard at selling as she once had, but she was happy to have a few "very interesting listings," including The Castle. In the naturally lit second floor studio in her home, she painted flowers, red and yellow and all shades of blue and purple and white flowers arranged artfully in vases and bowls and baskets.

"I paint them upstairs and then bring them downstairs to look at later. Sometimes I can see then what else I want to do to them."

By that time of her life, Dee was into touching up painted flowers and listening to books on tape. As much as when she was a child, she was into enjoying Beaufort's pleasures. Unlike most of her contemporaries, though, Dee's pleasures in the ninth decade of her life included showing—and

selling—Beaufort's property, property with solid roofs and reinforced sills and fresh paint, property with surprisingly high price tags. She offered potential buyers of The Castle personal insight. It was located, after all, in one of the nation's most livable cities, several notches up from the "rundown town" Dee recalled from her youth.

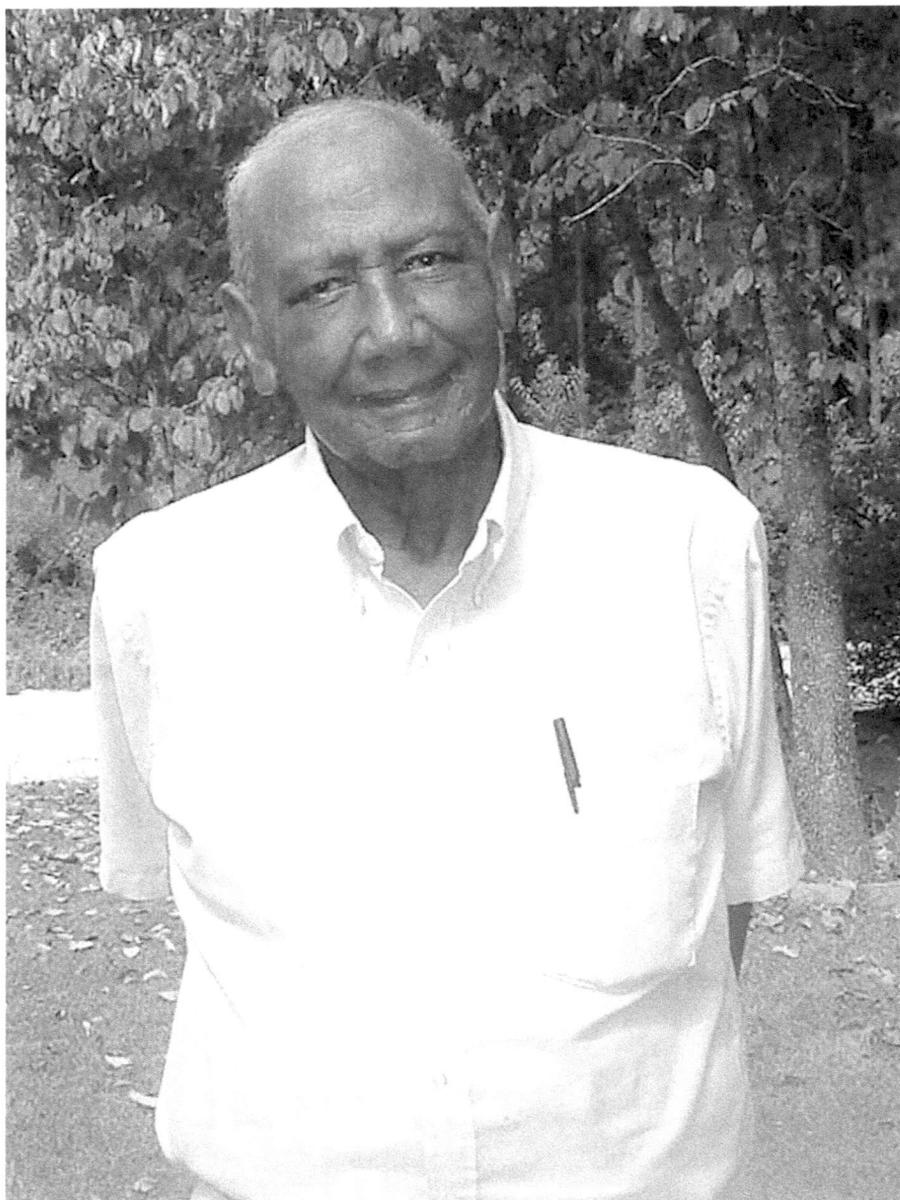

Norman Banner.

MECHANIC AND SENIOR DEACON

Norman Banner
born 1919

Once, after heavy rains, the preacher baptized "six or eight head" in a ditch waist deep in water.

Looking back, Norman Banner recalled the names of the mules he plowed: Jerry, Carrie, Bet and Sharon. Fine animals they were, strong and willing and able, valuable in the truck farming community of Lobeco in Beaufort County's Sheldon District. From early spring to mid-summer, Norman's grandfather had plenty of vegetables growing: tomatoes, beans, Irish potatoes, sweet potatoes, okra, watermelon and cantaloupes. In the fall he planted turnips, collards, cabbage and onions. By the time Norman graduated from fifth grade at Lobeco Elementary School, he had become an essential worker, a proud worker in his grandfather's farming operations.

After the mules, Norman cultivated crops with a tractor. By the age of twelve he was driving a truck. By the age of fourteen, he was hauling vegetables to the Savannah City Market.

"My grandfather taught me how to do things so I knew how," he said.

A SERIOUS STUDENT

Working hard in the sandy fields with his hands did not keep young Norman from his lessons. He liked using his mind, liked school. It was

so obvious that he enjoyed learning that a man named Mr. Norton
offered to tutor him at night. "He did it for free, but we would give him
a little sweet potato for payment," Norman said. "That lasted until I
was about fifteen." Norman finished eighth grade at Davis Elementary
School and then earned a high school diploma in adult education at
Robert Smalls High.

From his childhood on, Norman played various roles in the tedious
movement to overcome racial prejudice.

"Thing was I was a good student," he said. "I had a white friend,
John Butler Jr., about my age, who didn't like to study. His parents
found out that I did like to study, so they set aside a special room for
us to work together on the lessons. John would study along with me,
and that helped me and him. We weren't in the same school, but we
still could study together. I was always a little advanced, a little ahead
of my class.

"Sometimes when we were playing together, riding the horse or
something like that, John wouldn't want to come inside to eat a meal.
So his mother would invite me to come in with him. I would sit at one
table to eat, and John would sit at the other table. That's how it was in
those days. The black and white didn't eat at the same table."

For fun in Lobeco in those days, there was what Norman called
a "joint" with a piccolo, a place for music and dancing on Saturday
night. There was baseball. The Lobeco Yellow Jackets played the Dale
Tigers and other teams from other communities. And there was Mount
Calvary Baptist, a gathering place, a place to see the neighbors and
share food as well as worship God.

"The churches in those days were packed on Sunday, and the outside
would be crowded, too. There was no radio, TV, cars or anything
so church was an important part of everybody's life," Norman said.
Baptisms were festive high tide occasions in Whale Branch, Wimbee
Creek and Huspah Creek. Once, Norman recalled, after heavy rains, the
preacher baptized "six or eight head" in a ditch waist deep in water.

At the age of fifteen, Norman went to work for Tidewater Construction
Co., building the Hunting Island Bridge. The next year, he got a job with
Angle Construction Co., building facilities at the Parris Island Marine
Recruit Depot. Then, after working for a couple of years in civil service
on Parris Island, he was drafted into the United States Army.

A SERIOUS SOLDIER

In 1943, the military rules and the customs continued to separate blacks and whites, same as in South Carolina. As the American forces prepared to invade Normandy in 1944, a white soldier turned to Norman Banner and asked a question other whites there had wanted to ask: "What are you [a black man amidst all these whites] doing here?"

Norman didn't have to respond. He recalled that the colonel in charge answered for him this way: "You better be glad he is here. I can tell you that. This soldier is here because he has gone to chemical school. He knows what we need to know about mustard gas and the other gases the Germans might use."

Norman earned the EAME Service Medal with two Bronze Stars, a Good Conduct Medal and the World War II Victory Medal. One day in 1994, fifty years after the Allies' liberation of France, in his mailbox in Lobeco he received a letter expressing profound gratitude from Francois Mitterand, president of France. About ten years later, almost sixty years after the war ended, Congress honored Norman along with 111 other South Carolina veterans with the French Jubilee of Liberty Commemorative Medal for "meritorious service."

After World War II, back in Beaufort County, Norman was hired as the first black auto mechanic on Parris Island. If you succeed, he was told, that will mean that the civil service will hire more blacks for such jobs. "I knew I could do it. I just had to work hard. Within eleven months, they had hired two more blacks," Norman said, "and I was on top of the world." Norman continued to take classes and to win honors for service in Parris Island's motor transport division. When he retired December 14, 1981, the commanding general awarded him a certificate of appreciation in "grateful recognition of service faithfully performed."

During Norman's working years, Lobeco changed. One by one most of the area's big farmers quit farming. One by one the area's black families saw their sons and daughters go north for wage-paying jobs. A few black people found work in long commutes away from Lobeco in the construction and resort businesses. A few people, mostly white, found cheap land and lovely vistas and built new homes in Lobeco.

CONTRIBUTIONS AS A RETIREE

In 2005, living on the fourteen-acre tract left to him by his grandfather, Norman Banner observed that a lot was different from how things were

when he first began to walk behind the mules of his grandfather, cultivating some of the famous truck crops of the '20s, '30s and '40s. The fields were no longer being plowed and planted. The church had a pool for baptism by then, and church services weren't crowded anymore. Norman continued, nevertheless, as he had all his life, to provide "service faithfully" to his family and his community.

He and Evelyn, the girl from Dale he married in 1951, expressed pride in their daughter, a nurse, and their son, a pharmacist. "I was old enough when I married that I could make a good selection," Norman said, "so Evvy and I have argued but only inside the house and only briefly. We have never been apart. We had good children, too. They always worked, washed dishes, cut wood, whatever. Then both got their master's degrees."

By then, Norman was senior deacon at Mount Calvary Baptist Church, with responsibilities for peacekeeping in the community. "Through the deacons, we still work out disputes sometimes, and the minor crimes. When something comes up, we hold a meeting to go over the arguments, and we always work with the arresting officer if there is one. We use the Bible to give us advice on how to handle these things," he said.

For Norman personally, Sunday still was a big day on account of the worship services. But the most important night of the week was Tuesday night, the night of Bible study. "On Sundays you get the sermon, so you just listen. On Tuesdays, you can say, 'Hey, Reb, wait a while. Let's talk some more about what you said.' That way you can get the understanding, and that's what's good about that."

Early in the twenty-first century, with a pension and a comfortable home, Norman Banner was a man of quite some understanding. He understood that the life he knew in Lobeco as a child and as a young man was long gone. Broom straw, goldenrods and morning glories grew out of soil that once raised tons of vegetables for northern markets. The wind whistled through tall pine trees standing in the fields he and his grandfather's mules had cultivated together.

PERSPECTIVE ON THE BIRTH YEARS
1920–1929

What a privilege, growing up in northern Beaufort County in the 1920s. Families knew one another and looked after one another. Social life and the value systems evolved through the churches and the schools. The waterways, composing half of the total area, provided recreation, transportation and food. After a couple of centuries of various kinds of ferry operations between the city of Beaufort and Lady's Island, in 1927, a drawbridge finally crossed the Beaufort River.

On the world scene, the League of Nations formed in Paris and moved to Geneva. In the United States, Sinclair Lewis wrote *Main Street* and Louis Armstrong made wildly popular music. On October 28, 1929, the U.S. Stock Exchange collapsed.

Aside from births and marriages and deaths, not a lot was happening in the South Carolina Lowcountry, and yet the players of that era put on quite a performance.

Lucille Culp. *Courtesy of Lucille Culp.*

A VIEW THROUGH A FINE LENS

Lucille Clara Hasell Culp
born 1921

Along with 156 old cameras, her old photographs constitute a treasure for those impressed by documented cultural history.

Every woman who's ever had her picture made deserves having her reality handled tenderly in the darkroom, said photographer Lucille Culp. The same was true for every man. Even Beaufort's venerable St. Helena's Episcopal Church benefited from Lucille's tenderness. Her photographs of the building's stark masonry exterior include edging by the frills of leafy dogwoods, real but just so. In her mind, "It needed a feminine touch."

Beginning in 1981, when she closed Bay Street's Palmetto Studio, Lucille did touch-up, clean-up and fix-up work on old photographs. For various customers, she performed near miracles on paper, creating good-looking reproductions out of everything from ragged snapshots to faded eighteenth-century portraits. She tamed unruly hair, removed "busy" background, erased whole people when their presence was no longer desired in the picture. She said she wasn't changing history, but was just preserving it in its most appealing images.

Along with reproducing pictures that had lost their luster, Lucille also saved and printed photos of long-ago Beaufort scenes and long-gone Beaufortonians, many of the images on aging film negatives never printed until she retired. She labeled and organized some of them. In albums and

on poster boards and in frames and in stacks and piles of materials in her Ribaut Road home, Lucille stored pictorial vignettes of Beaufort County and its people, going back more than sixty years. They included oyster boats and shrimp boats, antique Packards, waterfront warehouses and street scenes of decades past. They included children, families and folk, black and white, who made Beaufort what it is today.

Along with 156 old cameras, her old photographs constituted a treasure for those impressed by documented cultural history. Knowing that new technology could facilitate enhancement and cataloging of the images taken decades ago, she regretted not being computer literate. Still, with the counsel of historians, she sorted out options for their best use.

As a retiree, Lucille enjoyed doing things she had not had time to do in her forty years of working full-time.

WESTERNER BY BIRTH

Lucille's father grew up in Beaufort County's Okatie section. In the second decade of the twentieth century, he was doing land-surveying work that took him to Colorado, where he married. When Lucille was born in Denver in 1921, the country was in the throes of Prohibition and the newness of the Nineteenth Amendment giving women the right to vote. As a child growing up in the shadow of the Colorado Rockies, after the flood along the South Platte River, Lucille rode a horse to school and to her violin lessons.

Then Lucille's Aunt Nellie Hasell Fripp, her father's sister, was widowed and suddenly needed help to run the Fripps' truck-farming operation in Beaufort County. So in 1933 the Hasell family—Lucille and her three brothers, along with her mother and father—moved from the ranch in Colorado to Old Oak Plantation on the banks of Broad River in Burton.

A stranger in low-lying, marshy Beaufort County at the age of twelve, Lucille found herself yearning for the soaring mountain peaks of Colorado. She missed her horse, her violin and her childhood friends. Desperate, she walked one day to the Beaufort bus station to ask about bus fare to Denver. A ticket cost twenty-five dollars, a sum she could not possibly have produced at the time. So she stayed put.

Diphtheria followed by temporary paralysis because of the treatment for diphtheria kept Lucille confined to home for so long that she lost a year of school before graduating in 1940. Then she worked at various jobs for short periods of time before hearing about a job in the darkroom of Palmetto Studio.

"I had always been curious about how you got those pictures out of a roll of film," Lucille said, remembering her early fascination with the photographic processes. "When I finally found out how it's done, I told my mother, 'I know what my life's work is going to be.'" So she applied for the Palmetto Studio job, was hired and so found a way to do her life's work in Beaufort. Her fascination with the miracle of extracting pictures out of film never waned.

HEADSHOTS OF MARINES

Palmetto Studio took the photographs of hundreds of Marines stationed on Parris Island during World War II. To expedite the process, the studio owner, the county's only consistently full-time professional photographer at the time, kept replicas of the non-commissioned officers' dress uniform in the studio. Slit in the back, they could be slipped on and off quickly, and the various medals, ribbons and other decorations appropriate to each soldier could be attached temporarily as he sat for his military portrait. Along with pictures for school annuals, babies, family portraits, weddings and the processing of film from the growing number of snapshot cameras, the steady customer base of military personnel provided a good income for the studio.

By 1944, at the age of twenty-three, when the opportunity arose to buy the business, Lucille put up $2,000 and Palmetto Studio became hers. Besides doing work she liked in a community she had come to care for, suddenly she was making money. In a single year, she bought herself a diamond ring, a fur coat and a car. Intent on building her business, she also bought a lot of good equipment. In 1946, she bought a state-of-the-art speed graphic camera, one with a lens so fine she continued to use it for more than fifty years.

After World War II, construction of the U.S. Naval Hospital brought an attractive construction worker to town, one who happened to come into the studio one day and happened to fall in love with Lucille. After they married in 1948, William "Bill" Culp eventually came into the photography business with his wife. For a while, the business thrived. Lucille and Bill Culp played an important role in the lives of hundreds of Beaufortonians as they took the pictures of the babies, the students, the brides and the couples celebrating twenty-fifth anniversaries.

In the 1960s, the business dynamics in Beaufort changed. Competition took away the contract for the school yearbook pictures. Often, after the photo of a newly engaged bride-to-be was published in the *Beaufort Gazette*, a

local photographer competing head-to-head for business would go after the more lucrative contract for the wedding to follow, presumably undercutting the Culps' price. To compound the problem, Olan Mills, a national photo business, distributed discount coupons on Bay Street, in front of Lucille's business. Even the snapshot customers disappeared, as they began sending their exposed film by postage-free mail to Jack Rabbit studios.

The Culps' Palmetto Studio did not thrive on the intense competition for business. In 1969, Bill left the studio and went back into construction work. He died in 1975. Lucille stayed in the studio a dozen more years before closing the doors and bringing the equipment home in 1981—forty years after getting a job in the darkroom there.

History and flowers

After shutting down her studio, Lucille Hasell Culp aimed her lenses and her interests most frequently at the past. She drew on the written word to make her contribution to the community's historical record. The heir of many of the Fripp family papers, Lucille gleaned what she could from them and made the stories available to others. It meant looking at faded, hand-written journals, diaries and records from the late 1800s and early 1900s, organizing, summarizing and in some cases translating. She was active in organizations focused on history and preservation and community charity. A master gardener, she showed off her mass of blooming bromeliads and gave away cuttings and leaves and rhizomes of many plants to spread her joy of gardening to others.

And Lucille continued into the early twenty-first century to share her written materials, her memories, her artistic talent and her stash of old Beaufort photographs taken in the old-fashioned way in an era that is no more.

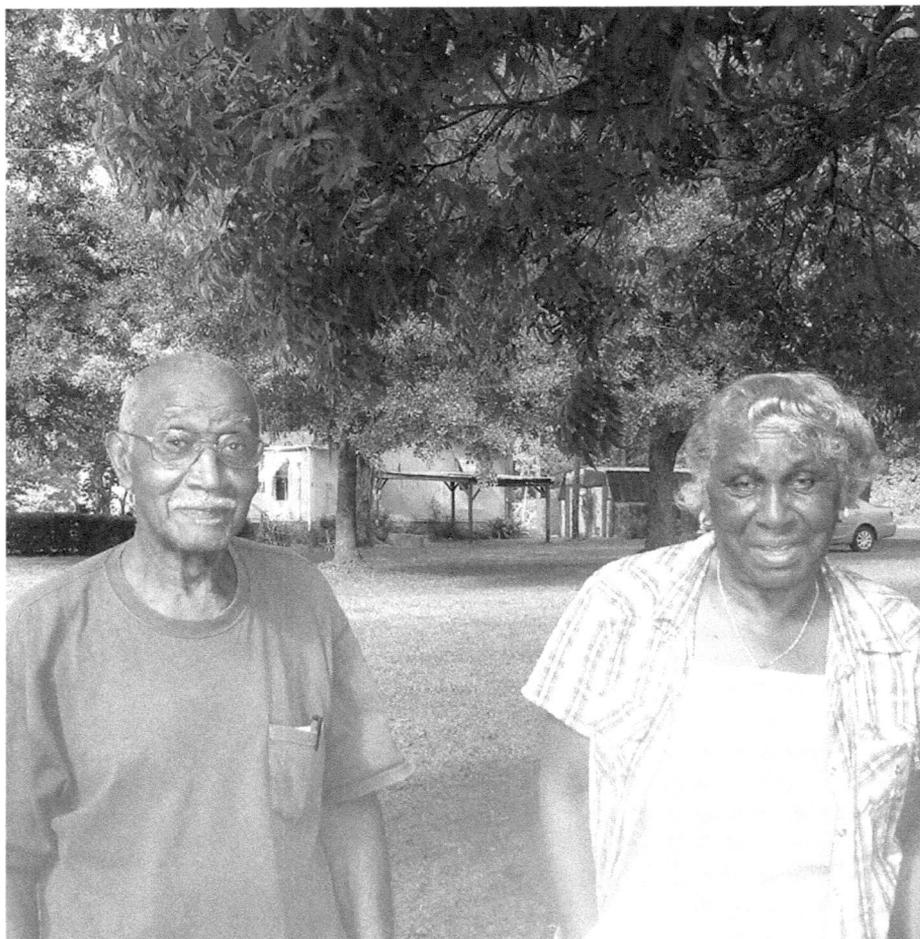

Johnny Blue and Lily Blue Chisolm.

Old-time religion in Sheldon

Johnny Blue
born 1923
Lillian Blue Chisolm
born 1926

"That's the oyster stew: oysters out of the creek, milk and butter from the cow."

Sunday worship service at Sheldon's Canaan Missionary Baptist Church started casually. A woman sitting near the front stood, told the story of an accident, an injury and a recovery and broke out in song, "My God Can Do Anything." Others joined in singing, then in swaying, then in clapping. The energy began to lift spirits.

There were prayers and readings, and then the ten-man-strong male chorus strutted up the aisle taking charge of the music, the keyboard and drums near the pulpit accompanying them, the congregation singing along. "Pass me not, O gentle Savior, Hear my humble cry." For the next hour or so, more prayers and readings were followed by announcements and encouragements, followed by reports on the health and condition of all sorts of folk in the community, followed by more hymns and spirituals with "amen, brother" interspersed throughout.

The spirituals were slow at first, almost soft, then faster and louder before they developed into a full-blown anthem of promise with everybody in the sanctuary moving to the beat, clapping, nodding, shifting from side to side in rhythm. "Farther along we'll know all about it. Farther along we'll understand why. Cheer up, my brothers, live in the sunshine. We'll understand it all by

and by." Nobody needed a book. They all knew the words. There was no timid mouthing. The pitch was low enough for everybody to sing at full volume.

There were two collections, one for the church, one for charity. The serious but jubilant service had been under way for an hour or so before it was time for the sermon. Altogether, the Canaan Baptists would worship for a couple of hours or more.

At least one member of the male chorus understood with all his being that Sunday morning was the most important time of the week. For Johnny Blue, in his dark suit, white shirt and red tie to match the dress of his fellow choir members, that worship service connected not only with God but also with his neighbors. When the male chorus launched "Give Me That Old-time Religion," there was no doubt in Johnny's mind that they were singing about the most important thing in all the world.

Household of many

Johnny Blue and his sister, Lillian "Lily" Blue Chisolm, grew up just down the road from the church, a couple of miles off U.S. Highway 17. Counting Johnny and Lily's brothers and sisters, six children filled the small frame house. Counting the other children their parents raised, there were nine. Lily explained, "In 1938, my oldest sister had a daughter, Gloria. In 1939, Viola, my other sister, had a son, Josiah. Then we took in Leo, a cousin. I was thirteen years old when all that started, and I had to stay at home with my mother to help take care of them. That's just the way we handled it."

Life was simple but hard. Johnny and Lily's parents worked for Bray's Island Plantation, now an exclusive, expensive residential community but in those days a working plantation raising cattle, hogs and poultry. Their father drove a horse and wagon hauling garbage on Bray's Island. Their mother fed and watered chickens and plucked chicken feathers once they were slaughtered for the table or the market. The work was physically exhausting. Wages were small. The creek, the vegetable garden and the barnyard produced most of the family's food. Church provided recreation.

Children were taught "manners" in those days, Johnny and Lily said. "We had to watch our mouth, and we had to teach the little ones to watch their mouth," Lily said. "You got that right," Johnny said. The discipline did not stop at one's door but carried over from house to house in the loosely organized village. Every child was expected to obey every adult who gave him directions, whether that adult was an aunt or an uncle or a grandparent or a neighbor. Children who disobeyed were instructed to go

cut their own switch from a bush, bring it back to an adult and bend over to receive a "switching."

Four general stores furnished Sheldon with necessities the residents couldn't raise themselves. Lily remembered Wednesdays especially, the day the stores all closed and the white men who owned them—named Mr. Priester, Mr. Kinard, Mr. Mixon and Mr. Getz—came to the Blue family home for their midday meal.

MEALS OUT OF THE CREEK

"Me and my mother made oyster stew for the white men on Wednesday. You got to have the shucked oysters. And you got to have milk from the cow and butter made from the cream from the cow. And that's it. That's the oyster stew: oysters out of the creek, milk and butter from the cow. We made so much of that stew, and they ate it all."

The Blue family ate seafood so often in the '20s, '30s and '40s that by the time Lily was an adult, she didn't want to see anything on the table that had been harvested out of the tidal waters. By the time she was in her eighties, she said, "I look at oshtuh in the store and think, 'no, no, I don't want no oshtuh. Swimps neither.' We ate so much of them growing up that I can't eat them now."

Following the great exodus of southern blacks in the twentieth century, both Johnny and Lily migrated north for a time. Johnny was in New York City from 1948 to 1977, most of that period working in maintenance for RCA Communications. After Lily divorced, she took off for New York in 1964 and stayed until 1987, working in the garment factories. Both always had in mind that they would return to Sheldon when they could.

"Some people say they couldn't get used to the city. Well, I got used to it all right, but I didn't like it," Lily said, laughing. "It's too many people, and it's too crowded and too noisy, and I like to be in the country."

Johnny returned to Sheldon in 1977. Lily returned in 1987. Back "in the country" in Sheldon, they found their neighborhood quieter than ever, the young people having left by the dozens and for the most part not returning. "There's nothing much here for them," Johnny explained.

HEIRS' PROPERTY TROUBLES

They also found the fourteen acres of rural land they had inherited with numerous other kinfolk had become both a source of solace and a source

of contention. Their grandfather, April Blue, and their father, Arthur Blue, and his siblings had died without wills. The Blue family history had been beneficial on one hand, providing its descendants with inherited real estate, and detrimental on the other, leaving the title to the property in a tangle of ownership.

In order to solve the annual disputes over who was going to pay the taxes on the property and in order to build houses on it, Johnny and Lily had to get clear titles. "Some of the family members wanted to own but didn't want to pay taxes, so that was a problem," Johnny said. "And mortgage companies don't want to lend you money unless you have the ownership yourself."

Eventually, after some wrangling and planning and going to court, Johnny and Lily and their relatives were able to clear the title to their ancestral lands, their heirs' property, and use it to their benefit.

By the early twenty-first century, Lily and Johnny and sister Viola all lived within shouting distance of one another on their family land in Sheldon. Hardships and disappointments of the past haunted them occasionally, but mostly they lived in peace. From the porches in the neighborhood, they could hear crows cawing but not much else. On Sundays they praised the Lord for his generosity and his protection and urged the Lord to bless not only them and their families but their neighbors also.

The faith of their old-time religion gave them comfort and enabled them to comfort others. "Amazing Grace," they sang, at first slowly and reverently, heads bobbing. Then the male chorus picked up the pace and the volume, and with the help of the keyboard, the drums, the tambourines and the hand clapping, the whole congregation built the universally loved hymn into a joyful crescendo. Praise God. It echoed all over Sheldon.

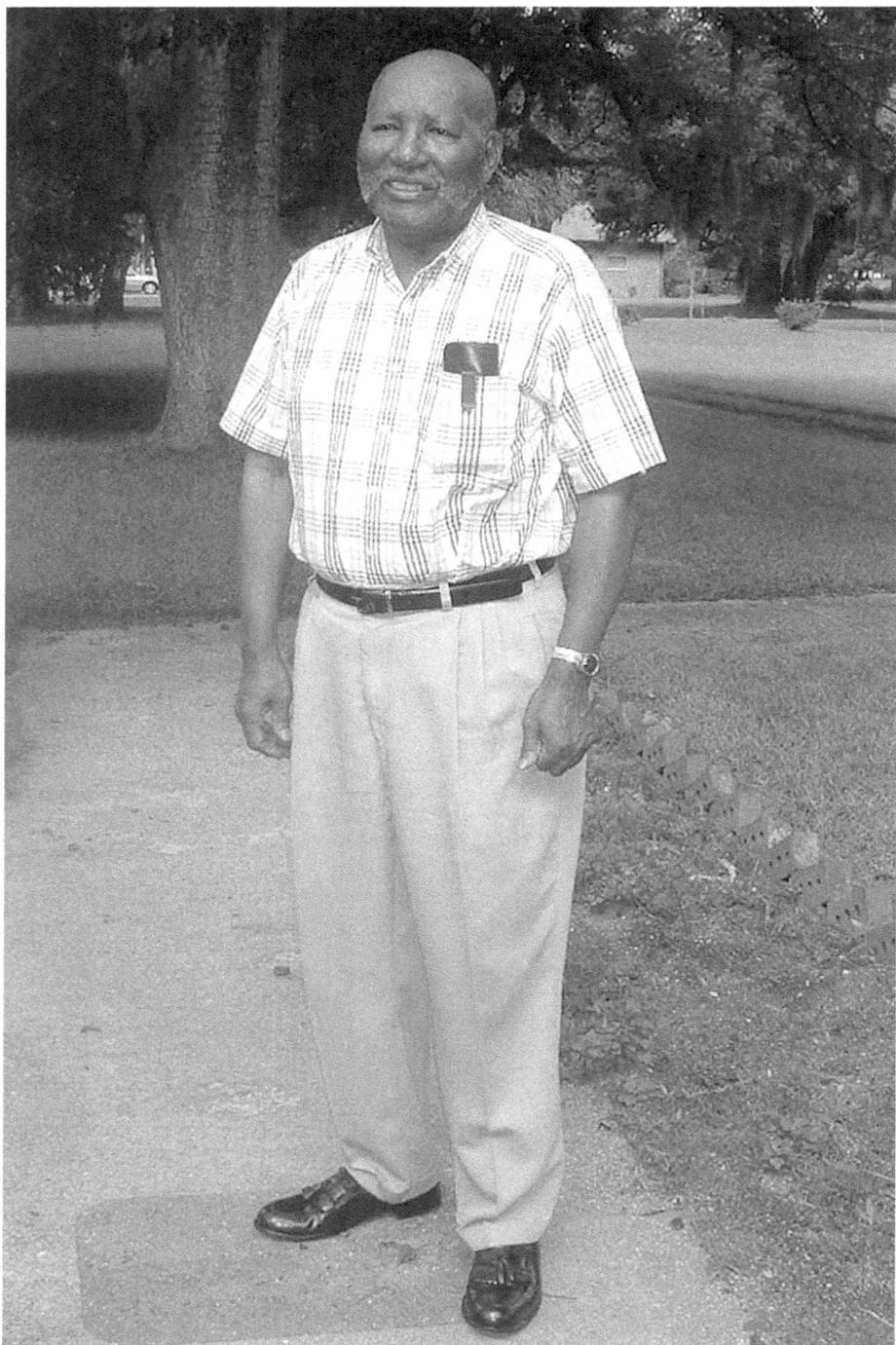

Robert "Ralph" Middleton.

"To raise a child"

Robert "Ralph" Middleton
born 1926

"I learned how 'the system' really works in places other than St. Helena."

Robert "Ralph" Middleton had the advantage in his early years of the old African tradition of looking to the entire village to raise each child. To his dismay, he found out as an adult that many other cultures do not handle their children that way at all.

Shortly after the last shot was fired in the brutal Civil War, a branch of the Middleton family of Wadmalaw Island bought eleven acres on Corner Plantation on St. Helena Island. In 1926, Robert was born just down the road from the Corner, on Croft Plantation, home of his mother's family. Along with parents, grandparents, aunts, uncles and cousins nearby, he had the nurturing neighborhoods of open, friendly St. Helena Island as his childhood legacy. Like most young people, he thought for a couple of decades that every community in the world must be like the one he grew up in.

Not to say that life was always swell for a young black boy on a remote island off the South Carolina coast in the 1930s. Robert remembered well when there was very little money in the household. For a snack or a meal he sometimes trapped sparrows, plucked their feathers, roasted them whole and ate the thighs. As an alternative, he had a cousin who could throw a brickbat and hit a wild rabbit. Rabbit meat was sweet. For the

yard game of "jacks," with no "jacks" from the store, he and his friends used peach seeds.

The summer before Robert was to go into the fifth grade at Penn School, his mother moved to Pennsylvania to work. Robert moved in with Benjamin and Catherine Boyd and stayed four years. Benjamin taught carpentry at Penn. The Boyds treated Robert like a son. He treated them like parents and in the tradition of the Lowcountry called them "aunt" (pronounced with a broad "a") and "uncle." In 1945, Robert Middleton graduated from Penn, a school he says that taught him lessons more valuable even than reading, writing and 'rithmetic—lessons in how to treat people.

THE PRAISE HOUSE

Along with Penn School and the sharing traditions of St. Helena, the praise houses had tremendous positive influence in the Lowcountry in the days of Robert's youth. Most neighborhoods had a small frame building where the neighbors gathered together two or three times a week to talk and sing and pray. Whatever dispute, heartache or potential crime brewed in the neighborhood might be talked out in the praise house meetings. The simple opening of "How goes it with your brother (or sister)?" extended the invitation for whoever was present to submit personal troubles to the counsel of the gathered. The praise houses provided opportunity to vent frustrations that might otherwise have boiled over into ill will. Problems the praise houses could not handle went to the church deacons. Only the few difficulties that overwhelmed the deacons ever came to the attention of the sheriff's deputies or the social service agencies.

"On St. Helena, the most important thing has always been family, and that word applied to a lot of situations. In the praise houses, people called one another 'brother' and 'sister,' and we treated them like 'brother' and 'sister.' The only way to get along on St. Helena was to help one another, and we did that."

BEYOND ST. HELENA

Sadness and despair followed shock when Robert Middleton learned that the way of working out problems that he had experienced on St. Helena did not prevail everywhere else.

He spent two years in the U.S. Army and Air Force learning diesel mechanics before entering Howard University in Washington, D.C., in 1947. He majored

in sociology, got married, worked for the U.S. Postal Service and in 1954 joined his black colleagues in celebration of the *Brown v. Board of Education of Topeka* Supreme Court decision outlawing public school segregation. He returned to Howard in a few years to get a master's degree in social work. By then it was 1958, but as Ralph recalls, "Everything was still segregated."

As a new social worker, well educated and with his heart in the welfare of the people he would serve, Robert was startled first by the realities of inner city Baltimore, Maryland. "That's where I learned how 'the system' really works in places other than St. Helena," he said. "People took advantage of one another. Adults would force children to steal for them because if the children got caught, they would only have to go to training school and nobody would go to jail. A man who fathered a child out of wedlock would opt for two years of prison time instead of paying child support. He knew that after the two years of free room and board in jail, he would be free."

On St. Helena a child needing a home might move in with a family member, a neighbor or a schoolteacher. In contrast, after Robert left the Baltimore job and moved back to Washington, D.C., he found five hundred children at a time living in "Junior Village," an institution of the city's child protective services department. Foster homes were scarce. "They might have relatives, but that didn't mean they had 'family.' When there is no family base, you are really hurting. Some of these kids would reach eighteen after years of being institutionalized for much of their lives, and first thing you knew they would be in jail. So they were institutionalized again. It was entirely predictable."

Robert's cases were different but not easier when he took a job as director of social services on the Mescalero Indian Reservation in New Mexico in the mid-1960s. "The Mescaleros were an Apache tribe, and a part of their culture involved leaving children alone for them to develop their independence. Well, I had a problem with that when the parents might be off feasting in another area, drinking for a week, neglecting the children. They had a very outspoken Apache chief at the time, and he did not like my child-care standards. And I did not like his."

In 1969, a year of restlessness, protest, civil and uncivil disobedience, Robert moved to Washington for the third time. A social services supervisor, then a branch chief in child protective services there, he found a city government and a Congress unable or unwilling to spend the money to do what he believed should be done for the most vulnerable members of the hundreds of fractured families under his jurisdiction. Then real estate prices and rents went through the roof, the mental health institutions

discharged thousands of their patients and the public shelters for the homeless and children filled up.

"Sometimes, after an eviction because somebody couldn't pay the rent, we would have to arrange for hotel rooms for children with families. What else could we do? Leave them on the streets? Then Congress wouldn't put up the money for the hotel, and the hotel couldn't stand not to get its money. It was a time in this world." Neither economic activity nor government programs nor court-mandated integration nor well-meaning charities took care of children the way they had been taken care of during Robert's childhood on St. Helena.

BACK HOME

Robert retired from social work in 1986. In 1989, he and his wife, Lisa, moved back to St. Helena to care for the retired Penn School carpentry teacher who had taken him in as a teenager. By then, Mrs. Boyd had died, and Mr. Boyd was blind. A short time after Robert returned to live on the island he grew up on, Mr. Boyd died, leaving his property, including a home and its furnishings, to Robert, the young man he had called his "foster child."

"We had learned on St. Helena that you cannot separate yourself from others. We saw that the community gave to us. We learned from Penn School and from the culture on St. Helena to give back to the community. That's how we live here." And so Robert Middleton became a leader in efforts to preserve the best of the Lowcountry as changes came rushing toward it.

One of Robert's greatest fears at the beginning of the twenty-first century was that St. Helena, like many other places, would be ruined, that greed and rampant development might turn it into an island of divisiveness. Since the praise houses didn't function as they did in the old days, conflict could be hard to eradicate. To Robert, another way to ruin St. Helena would be to pour more pavement on her. Robert said he had seen plenty of asphalt and concrete go down where trees once stood, but never in his life had he seen pavement ripped up and the soft soil beneath it restored to its natural condition.

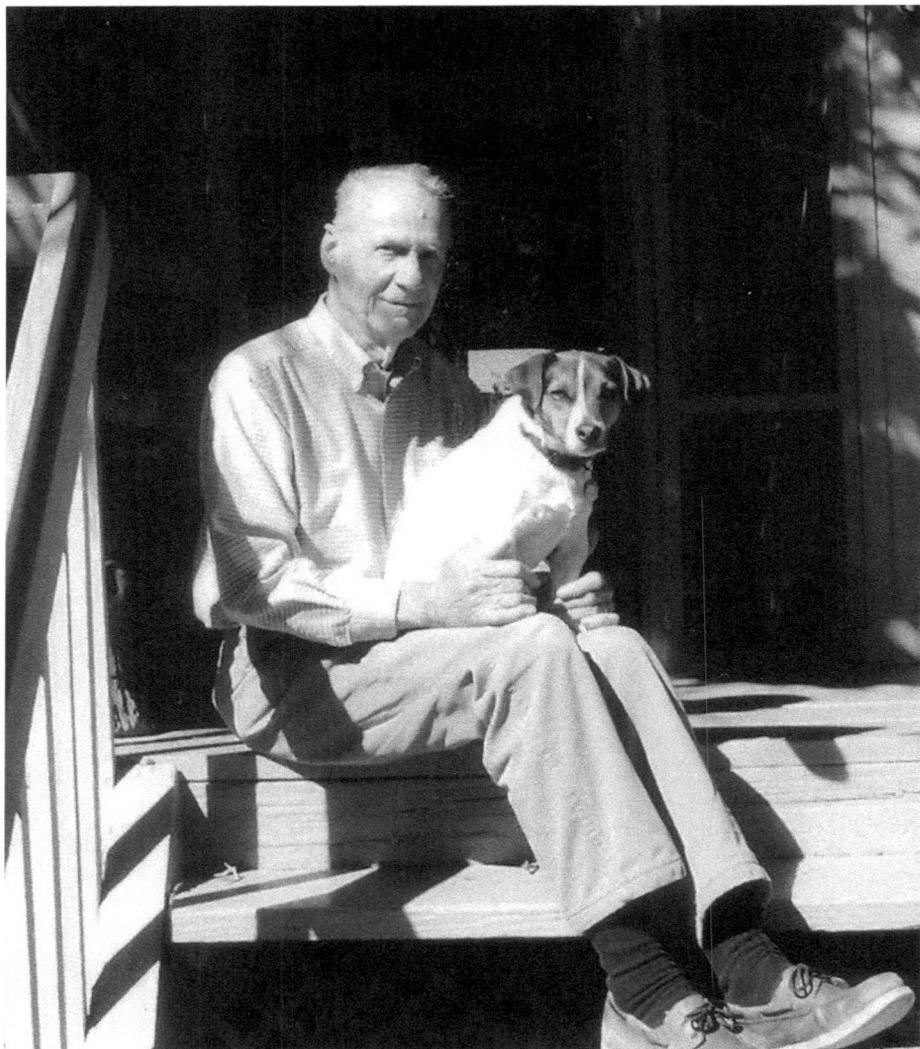

Pierre McGowan and "Junior."

Still listenin' for the bobwhite

Pierre Noel McGowan
born 1926

Pierre was about six when he started going with his father to the barrier islands to hunt deer and ducks.

Some childhood it was. One of only a handful of white families on St. Helena Island, the McGowans lived in the midst of a Gullah community numbering about five thousand. Sam McGowan, the father, delivered the mail six days a week and in his spare time took care of the real business of his life: hunting quail and duck and deer and dove in the fields and woods, fishing in the creeks, the sounds and the surf. Nancy McGowan, the mother, mostly went along with whatever Sam wanted except that in 1931 she took her three young sons to visit her family in France. A year later, when Sam picked up Nancy and the children at the train station in Yemassee, the little boys chattered away in French. Over the next few weeks, they had to relearn the familiar English—as well as the Gullah of their St. Helena neighbors.

Some childhood it was for Beau Sam, born in 1924; Pierre Noel, born in 1926; and Edward Perrineau, born in 1928. Sam, the father, was a member of Charleston's St. Cecelia Society and the Charleston Yacht Club, but his most important memberships were with his poker buddies, his gigging partners and his neighbors with dogs good enough to flush quail every time out. Nancy, the mother, was a member of Beaufort's

prestigious Clover Club and, equally important, a member of the informal association of famous female cooks and well-known health care experts of St. Helena Island.

"It was a great life," Pierre said at the age of seventy-eight, "and it's still great for me." It was so great he wrote one book about it, *The Gullah Mailman*, and when I interviewed him was about to send a second book, *Tales of the Barrier Islands*, to a publisher.

DELIVERING A FEW LETTERS A DAY

Pierre believed that Sam and Nancy McGowan were able to land on St. Helena Island because Sam's mother used her influence to secure the postal service job on a remote island for her wayward son. Widow of an Abbeville attorney, she lived well in a house she had built in 1915 at 5 St. Michael's Alley in Charleston. She had sent Sam to the University of the South, Sewanee, Tennessee, and to the Biltmore Forestry School; had set him up in a shoe store in Augusta, Georgia, and in a tire store in Akron, Ohio; but she had not seen Sam McGowan succeed anywhere. Finally, when Sam looked at all the hunting and fishing potential at St. Helena, he figured that delivering a few letters a day would leave him time to do what he really loved to do. His dreams were about to come true.

Nancy had come into Sam's life because she was sent from her French country home to take care of an uncle, the minister of the French Huguenot Church in Charleston. Sam and Nancy met on St. Michael's Alley, married in Sam's mother's summer home in Tryon, North Carolina, in 1922 and moved to St. Helena in 1925.

Some house they moved into. It came from Sears, Roebuck and Co.—beams, rafters, flooring, joists, walls, everything numbered ready for assembling into a two-story dwelling with basement. A North Carolina carpenter who was also a boat-builder put it together. The house is no longer in the family but was a prized structure in the twenty-first century, occasionally offered on St. Helena Episcopal Church's annual Tour of Homes.

Pierre was about six when he started going with his father to the barrier islands to hunt deer and ducks and about eight when he shot his first quail. He felt like a really big boy when his father let him use his fine Parker double-barrel shotgun for rabbit hunting. Hunting was just what Pierre and his brothers did when they weren't in school.

Except that they also went fishing. Sam taught them to fish for drum in the spring with a hand line, to gig for flounder and trout, to harvest the

varied, prized bounty of the vast estuarine system in which they lived. By the time the boys were in their teens, they knew the waters so well that Sam and Nancy let them take the twenty-foot cypress bateau with the ten-horsepower Johnson motor anywhere they wanted to go. A few times they had hair-raising adventures in winter squalls and summer storms. None of what might have been frightening experiences for most teenagers deterred them from the good life of fishing, always fishing, or just boating, or camping on one of the hundreds of islands that make up Beaufort County.

SEA ISLAND INTEGRATION

In that era, across the South, and for the most part, across the nation as well, blacks and whites understood "their place," and "their place" was not together. Schools and churches and other public facilities accommodated either blacks or whites but not both. Nobody talked much about discrimination but everybody discriminated. Sam, Nancy, Beau Sam, Pierre and Edward McGowan lived in a different world. Their world was St. Helena Island, where blacks outnumbered whites about one hundred to one. The McGowans and their black neighbors shared fish from the creeks and beans from the gardens with one another—and stories, year-round. They celebrated together, and cried together. They became best friends. For Pierre, those friendships lasted a lifetime.

After graduating with a civil engineering degree from The Citadel in 1952, Pierre immediately began to wonder how he could manage to make a living and also live where he could hunt and fish. It took him less than five years to figure that out. He worked at the Savannah River Plant, and then in Charleston, before becoming the base maintenance engineer at the Marine Corps Air Station (MCAS). Pierre and Faye Philips McGowan, a Beaufort girl herself, by then a nurse, lived in a cottage at Frogmore while building a house in Beaufort.

Pierre was back in his home territory, back in the woods and marshes, back in the place he loved. With partners he leased Spring Island for a few years, and from 1944 to 1991 had the advantage of a two thousand-acre quail-hunting lease his father initiated on St. Helena. The lease price in the beginning was ten cents an acre and was not much more by the termination. From time to time Pierre had the huge dilemma of whether to go fishing or hunting, but he never had the dilemma of not having anything to do.

For several decades, Pierre and Faye focused their attention on their three daughters and one son. They lived on Audusta Street seventeen years,

lived in Spanish Point for a few years and then bought a townhouse in Jericho Woods. After Pierre retired from MCAS in 1982, he worked briefly for Ted Turner as resident caretaker of St. Phillips Island, a low-lying strip of woods and wetlands just off Port Royal Sound. Pierre thought he'd died and gone to heaven. Faye, who had to commute by boat to her job as assistant director of nursing for the Bay View Nursing Home, thought he'd gone crazy. They made it through the first six months' commitment on St. Phillips before moving back to Beaufort. "If I was single, I'd live there right now, but I don't want to be single so I guess I have to live in town," Pierre said, laughing.

After the St. Phillips's venture, in 1985 Pierre built with his own hands a cottage on Dory Island, just off St. Helena Island's Seaside Road, a piece of property his father had bought in 1926 for five dollars. It's a getaway house. From the front steps Pierre could watch herons and egrets and hear a kingfisher. In the twenty-first century, Pierre was hard at work building a houseboat and still gigging for flounder and trout a couple of nights a week. For almost two decades he had the responsibility of supplying the main ingredient for First Presbyterian's annual fish fry for about three hundred people: flounder. He also drove Mobile Meals around the community.

By then, Pierre's two brothers had been far away for a long time. Beau Sam had been living on Jekyll Island for more than forty years, and Edward Perrineau was living in Arizona.

As for Pierre, the tidal water of Trenchards Inlet, Skull Creek and Harbor River continued to course through his veins. He was where he wanted to be, doing what he loved doing, same as Sam McGowan, his father, the Gullah mailman. One thing was different, though. "There used to be two coveys of quail on Dory Island. I haven't seen any now in about fifteen years. I don't know why the quail are all gone. It might be the fire ants. I don't hear the quail anymore. I keep listen', though."

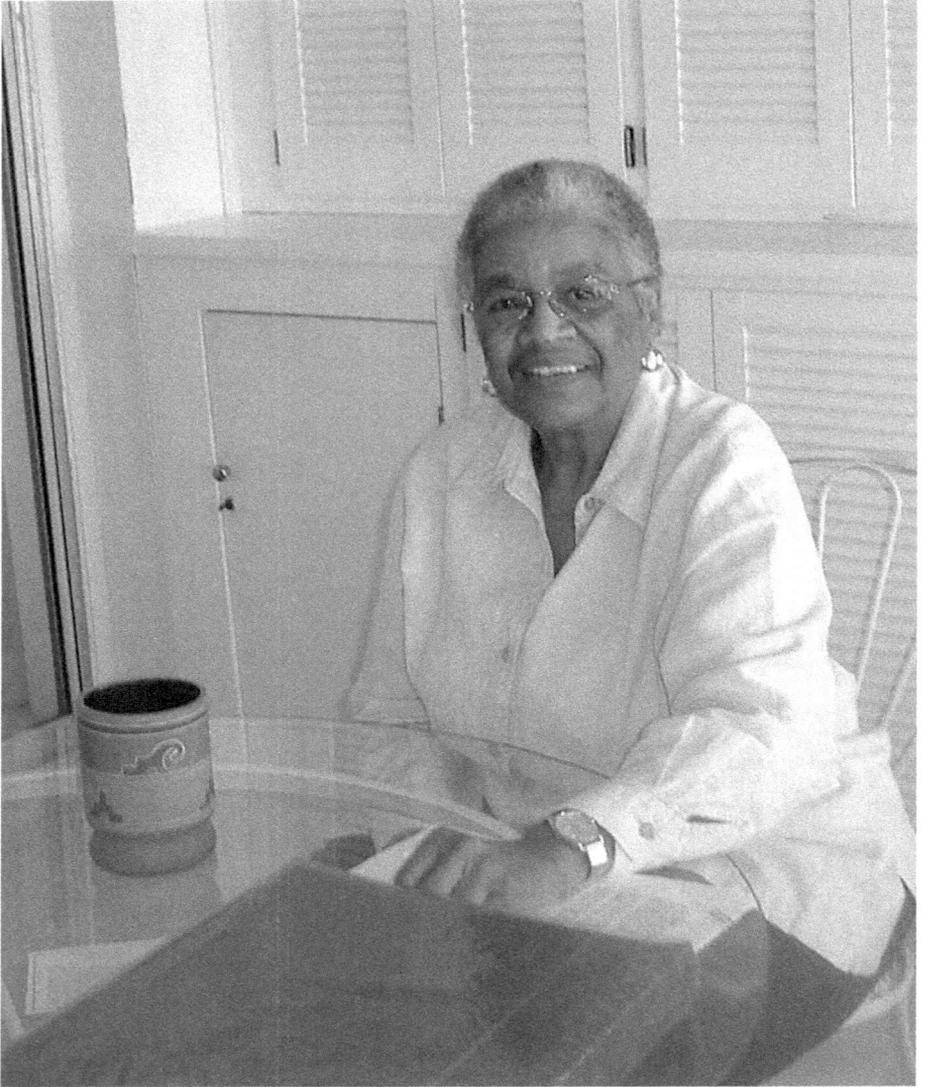

Eleanor Barnwell.

Family traditions served her well

Eleanor Inez Barnwell
born 1928

"Whites and blacks were separated by law and custom. It was a despicable period. Thankfully, I say, things have changed for the better."

Eleanor Barnwell, who grew up on Lady's Island, spent about forty-five years away from the Lowcountry. Following graduation from Penn School, she earned a BA degree from Bennett College in North Carolina, a master's degree from Syracuse University in New York and a doctorate from Wayne State University in Michigan. Determined as a young woman never to be a schoolteacher, she worked in other professional capacities all of her adult life, ending her career as director of community relations in the Detroit school system.

From time to time, during her years up north, Eleanor would recall the clucking chickens and other animal noises back in the Eustis community of Lady's Island, where she had been born in 1928. She would think about the pre-dawn stirrings of her young brothers as they scrambled from bed to get bait shrimp and minnows to sell to early morning fishermen. Close to her heart in those years she held the legacy of parents born one generation out of slavery, a man and woman determined to bring their children up in a home enriched by education, discipline and etiquette.

"I left Lady's Island, and I wouldn't take anything for leaving when I did, for the reasons I did, but I guess in my heart I never really left," Eleanor

said, smiling. "I came back often, and for twenty years funded a scholarship for local students in memory of my father. I hadn't really planned to come back here to live, but here I am, and I couldn't be happier."

In 1990 Eleanor came back home to care for her ailing mother. In her townhouse at Marsh Harbor, she read a lot, played golf and reveled in sunsets overlooking Broomfield Creek. She served on various nonprofit organizations' boards of directors and worshipped at Brick Baptist Church, as she had done throughout her childhood. As a "binyuh" from way back, she studied her family's history and shared it with "binyuhs" and "cumyuhs" alike. And what a history!

Eleanor's father, Benjamin Burdee Barnwell Sr., was born in 1892 in the Eustis community of Lady's Island, where his grandparents and parents owned the land they farmed. He was one of nine children.

Eleanor's mother, Wilhelmina Blanding Barnwell, was born near Ridgeland and raised in Beaufort, one of thirteen children, only three of whom lived to adulthood. There were white ancestors on both sides of her family. Wilhelmina's father, who died before she was born, worked as a lighthouse keeper and a deputy sheriff on Hilton Head Island. He was the son of a white surgeon who never married and the daughter of a well-to-do freedman, all from the Ridgeland area. Her mother was the daughter of a house slave and a white slave owner who had five children together. The slave owner employed the same governess for his two sets of children, those by his white wife and those by his black mistress. The siblings and half-siblings studied, played and ate together.

Today Eleanor can point to the graves of her grandparents and her great-grandmother in an African American cemetery near Ridgeland. And she can point to the grave of her great-grandfather—in a white cemetery across the road.

"Whites and blacks were separated by law and custom in most ways for many decades," Eleanor said. "It was a despicable period. We still don't like the name or the word 'plantation.' We still remember that long ago only a few white people would address black people as 'Mr.' or 'Mrs.' Thankfully, I say, things have changed for the better."

BENJAMIN AND WILHELMINA BARNWELL

After Eleanor's father, Benjamin Barnwell, graduated from Penn School, his father sold a cow and with the money outfitted him, bought him a train ticket for Virginia so that he could get to Hampton Institute and

gave him two dollars. Benjamin earned all of his Hampton expenses. After graduating, he came back home to teach, manage the farm at Penn and help his younger siblings continue their education. Then he got a job as the second Negro in the nation to be hired as a farm demonstration agent for the U.S. Department of Agriculture, a job he held for thirty-nine years.

Wilhelmina Blanding Barnwell, Eleanor's mother, a graduate of Mather School and Haynes Institute in Augusta, Georgia was teaching at the Shanklin School, as the Beaufort County Training School was commonly known, when she and Benjamin Barnwell met. After they married in 1925, she joined her husband on the faculty of Penn School.

In 1927, the Barnwells built what was called a state-of-the-art farm cottage at Eustis. Penn School selected their home as a "Better Home" and often took visitors to see the house as an example of how farm families might live one day. As long as Eleanor could remember, the house had running water, indoor plumbing and an electric generator. In that home were born five children, Eleanor first and then four brothers. Because of their father's job, the Barnwells had a telephone and a car, amenities rare on the island at the time. Their life on that farm contrasted with the lives of most farming families who lived in more primitive circumstances all over the island, the state and the rural sections of the nation at the time.

Benjamin Barnwell also ran a state-of-the-art farm. Working under Clemson College, he had the responsibility of convincing farmers to quit planting cotton, a cash crop no longer producing much cash, and to start planting vegetables such as tomatoes and cucumbers to market; also to raise chickens, turkeys, ducks, pigs and cows. Clemson and Benjamin pushed lettuce as a potentially profitable winter crop for local farmers, but among the island farmers it was not a familiar food and did not catch on quickly.

HOME LIFE

Benjamin was a deacon in the church, Wilhelmina was the church organist, and the entire family attended Sunday school and church regularly. "I don't recall them lecturing us much," Eleanor said, "but somehow there was an understood code of conduct for our lives—things Barnwells did or did not do."

Occasionally, and always for Christmas shopping, the family motored seventy-five miles to Savannah, through Pocataligo and Coosawhatchie because there was no bridge over Broad River. Sometimes they visited friends or family in Orangeburg or Charleston. Occasionally, they caught the steamboat in Beaufort to go to Savannah. Blacks rode on the lower deck,

whites on the upper. When Eleanor was seven, the Barnwells took a vacation to Washington, D.C., and New York City, patronizing the Esso gas stations along the way. Esso provided bathrooms for blacks as well as for whites. The entrance was always at the back of the station and marked "colored." "But at least at the Esso stations we could go to the bathroom," Eleanor said.

Benjamin and Wilhelmina subscribed to the African American newspapers and other periodicals and maintained a home library. Eleanor especially remembered books by and about black people. Both parents entertained the children by reciting poems from memory and talking about their college experiences. One of the uncles scared and fascinated them with tales of hags and jack-o'-lanterns and getting lost in the woods and rivers. Wilhelmina taught piano in her home. A friend told Eleanor that at one time in every church on St. Helena and Lady's Islands there was at least one child who could play for the Sunday school service because they "had taken lessons from Mrs. Barnwell."

At home, the Barnwells listened to the radio, gathering 'round especially for the Joe Louis boxing matches. They and their neighbors played croquet on the front lawn, table tennis on the extended dining table and baseball in their backyard. They had the creek for swimming and the colored section of the Hunting Island beach for picnicking.

At the age of twelve, Eleanor wrote an upbeat poem:

Our Family

I've four small brothers
Small but not meek
And we all live together
In a house by a creek
With Daddy and Mamma
And an old black cat
Who is seldom known
To catch a rat.
We sing and dance
And laugh and fight.
Sometimes we're wrong.
Sometimes we're right.
We love our house
Beside the stream
Where we can swim
And fish and dream.

Eleanor's line "fish and dream" may have been inspired by Eleanor's mother. "Oh, my mother loved to fish and she was good at it," she said. "When we children would get on her nerves, she would gather up her paraphernalia and go to the Chowan Creek Bridge. When she returned, her nerves would be settled, and she would have fish for supper. At one time she had put so much fish in the [community] freezer locker that she started selling them from there. She and my father could catch fish so successfully—Saturday was their fishing day—they supplemented our income with fish."

The ready availability of fish, shrimp, crab and oysters as grocery staples was a huge benefit to the family. "We could just get whatever we wanted out of the creek, and enjoy it day after day. For me, one of the hardest things after I left home was to see seafood for sale in the markets. At first, I just couldn't bring myself to buy it," she laughed. "It seemed to me it was something you shouldn't have to pay for. Of course, in New York and Detroit, I just had to get over that or do without."

EDUCATION AND MONEY FOR IT

Always, Eleanor said, the five Barnwell children understood when they were growing up that they would go to college. Education funds came from a variety of sources: special savings, Benjamin Barnwell's steady salary, Wilhelmina Barnwell's substitute teaching at Penn, the farm at Eustis, fish caught to sell as food, shrimp and minnows caught to sell as fish bait and piano lessons. Three of the five children became educators, two with master's degrees and one with a doctorate. One became a surgeon. One became a university-trained jazz musician. These children produced two lawyers, a family physician, two surgeons, a dentist, an educator, a health administrator and three involved in business.

In the eighth decade of her life, Eleanor Barnwell reflected with great joy, and with profound gratitude, on values Benjamin and Wilhelmina Barnwell established in their home beginning in the 1920s.

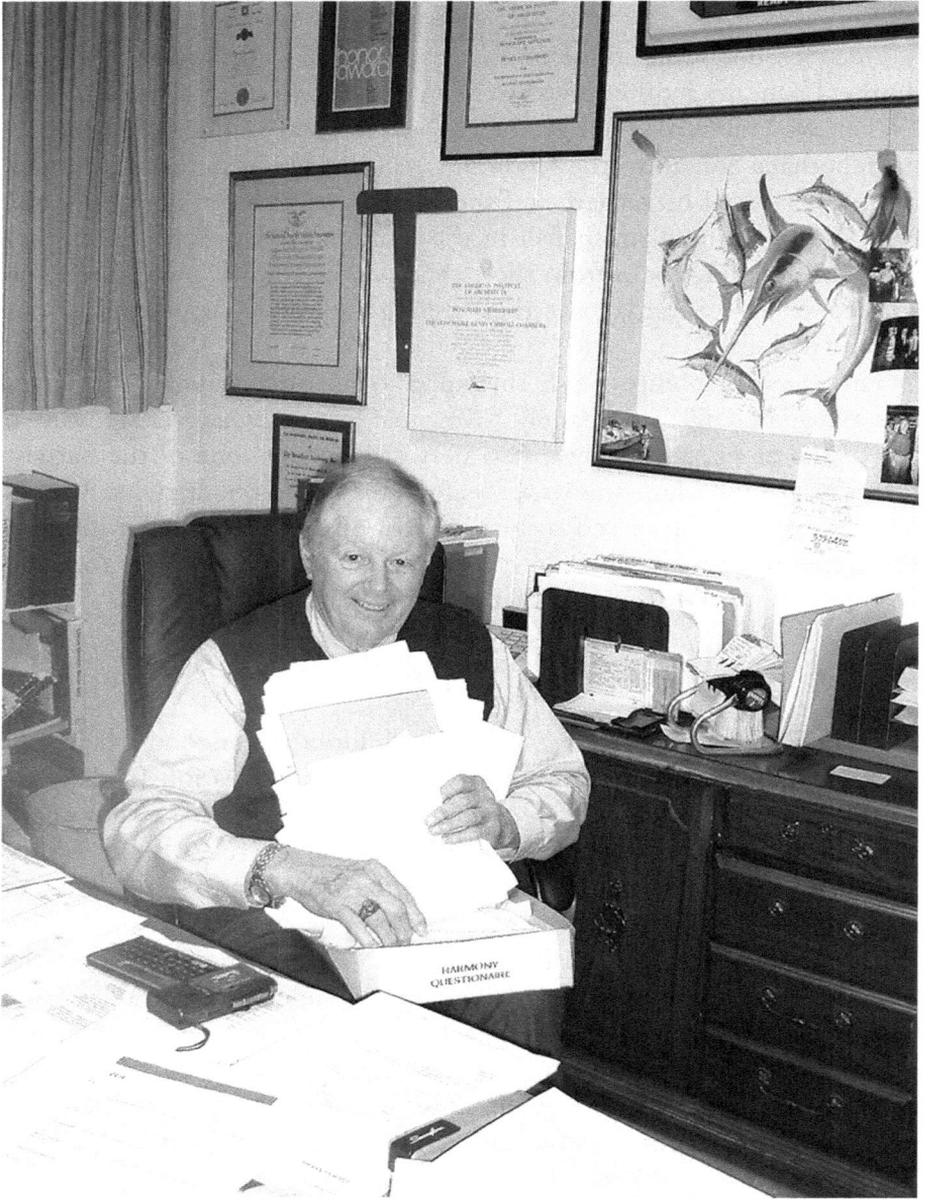

Henry Chambers.

A MOVER AND SHAKER

Henry Carroll Chambers
born 1928

"I was the only child in Beaufort Elementary School who took his milk to school in a half-pint liquor bottle."

An opera named *The Life of Henry C. Chambers* would feature Henry charming or clawing his way through every scene. He could play the emotional tenor or the unflappable baritone. In the opera's finale, Henry would stand tall and sing triumphantly.

Henry saw the story of his family through generations back as a part of his own story. Part of the sixth generation of his family to be born in Beaufort County, he was born at 500 Port Republic Street, a big antebellum house called Tidelands.

Henry's great-great-grandfather on his mother's side was a wealthy Jewish businessman from Austria who immigrated to New York in 1850 and came to Beaufort during the Civil War to look after his family's cotton brokerage operations. Home for that family—Moritz and Anna Pollitzer and their five children—was at Tidelands.

In 1880, Henry Chambers' great-grandfather, Henry Charles Pollitzer, who grew up at Tidelands, married Mary Eliott Guerard of Bluffton. Since the first Guerard in this country had arrived in 1680, the Guerard family had acquired sixteen thousand acres, land stretching from

Pinckney Colony to the Savannah River. By the time of the marriage, the Guerards of Bluffton were among the thousands across the South who were land rich and cash poor, their family fortunes having vanished during the Civil War. The Pollitzers were comparative newcomers and entrepreneurs. That Pollitzer-Guerard marriage united the New South with the Old South.

Through the Guerards, Henry Charles Pollitzer and Mary Guerard Pollitzer inherited Thomas "Squire" Pope's original carriage house on the May River, across Calhoun Street from Bluffton's Church of the Cross. They raised five children there. Their son, Henry Richard Pollitzer, married Mabel Duval Higgins of Georgia. They too had five children, which they raised on Charles Street, then at Tidelands.

AT HOME WITH GRANDFATHER

After one of Henry and Mabel's daughters, Virginia, married Carroll Jones Chambers of Hartsville and had two sons, Henry and Ben Chambers, the family tree began to look more like a live oak than a pine. Divorces were rare in the 1930s, but Henry's parents *and* his grandparents divorced at about the same time, throwing the family's stability up in the air. When Henry and Ben's mother, Virginia, moved to Little Rock, Arkansas, to get a divorce, Ben went to live with his grandmother Pollitzer at Tidelands, 500 Port Republic Street, and Henry went to live with his grandfather Pollitzer at Marshlands, 501 Pinckney Street.

The two brothers saw one another at school and at First Presbyterian Church, where Henry also saw his grandmother.

"It was a strange arrangement, but it was a great life with my grandfather," Henry said. "We lived together with the Baxter family, had a room with them, had the run of the place, Marshlands. My grandfather took me everywhere with him."

Henry's grandfather used his engineering degree from Clemson to serve the community he loved. He helped replace the city's shallow wells and some of the outhouses with the city's first water and sewer system. He helped install the city's first electrical service. Throughout the Depression, he worked toward economic development for Beaufort, a somewhat shabby town of about 2,500, and equally shabby Beaufort County, with a population of about 22,000. "He had the foresight, though," Henry said, "to lead a fight against International Paper Company's move to build a huge paper mill in the area."

Also a truck farmer, Henry's grandfather founded the Enterprise Ice Company, a business producing block ice to provide refrigeration for the vegetable crops as they traveled by truck and train to New York. When he died in 1938, while serving as president of the Beaufort County Chamber of Commerce, the chamber board passed a resolution praising him for his "tireless industry."

From time to time Henry would use an old-fashioned crank telephone to try to find his busy grandfather. By dialing a continuous ring, he would reach the operator. "Verona," he would say, "do you know where Granddaddy is?" It was a time and a place in which everybody knew everybody in town, so Verona could look out the window of the switchboard office and answer, "Henry, I see his car at the yacht club."

Henry came to feel good about his life in a one-grandparent family. Like his grandfather, he came to love Clemson College and the outdoors. Henry and his grandfather hunted together for quail, ducks, deer and doves, often on Guerard family land. Henry earned his Eagle badge as a young boy and as his own sons were growing up, served as scoutmaster and on Boy Scout councils at the local, regional, state and national level. Henry played on Beaufort High School's basketball team and its football team when they won state championships and also served as president of his high school student council.

"Now I have to tell this part, too," he said, laughing. "I was later told by my teachers that I was the only child in Beaufort Elementary School who took his milk to school in a half-pint liquor bottle. And one time, I was in the car with my grandfather when we were stopped at a roadblock. The police were looking for unstamped liquor. My grandfather took his pint bottle out of the glove compartment and stuffed it into the waistband of my pants and told me not to say a word. It worked."

Henry's family tree sprouted surprising flowers. Once, when Henry was a little boy, he was invited down to a yacht docked in the Beaufort River to visit fancy-dressed "[Great] Aunt Henrietta," also known as Princess Pignatelli. She was his mother's aunt. She had grown up in Bluffton, married the man who became heir to the Great Atlantic and Pacific Tea Company (A&P) chain stores and become heir upon her husband's death to about $200 million. Rumor had it that she was the richest woman in the world. Then she married an Italian prince, Guido Pignatelli. Aunt Henrietta and Uncle Guido built a thirty-two-room palace at Wando Plantation near Charleston and bought and preserved Charleston's famous Joseph Manigault House. Unforgettable characters, they were a part of Henry's family heritage.

In business in Beaufort

At Clemson College, majoring in civil engineering, Henry Chambers met Elizabeth "Betty" Brewer, Converse College's May Queen. She became his wife of fifty years. After Henry and Betty had a jaunt to Arizona when he was a first lieutenant with the U.S. Army Corps of Engineers during the Korean conflict, they traveled back to Beaufort with two young children to live. Like other Lowcountry natives who spend time elsewhere, Henry knew he was home when he smelled the pluff mud at the Whale Branch Bridge.

"I was fortunate to be able to come back. Most others I grew up with that went off to college had to go somewhere else to make a living." Henry said. "My grandfather's ice company was here, and by that time my mother had remarried, and my stepfather, Roscoe Mitchell, had started Burton Block, so I had something to come back to. My grandfather had left me shares of stock equal in value to those he left his own children.

"People were farming and shrimping and fishing, but Beaufort was in a pretty rundown era. The pigeons were living in the second floor of houses on The Point. Some of the big houses were just boarded up. The economy was pretty tight."

At last, in the 1960s, the economy loosened up. Burton Block began to sell building materials for the Marine Corps Air Station's construction. Sea Pines started building roads and tennis courts. Palmetto Dunes began to develop. As Hilton Head Island's growth took off like a rocket, Henry acted on a principle he had learned from his grandfather years earlier: "If you don't take a risk, you're not going to make a gain." Under Henry's leadership, Burton Block added asphalt and ready-mix concrete to its products and services. Burton Block's business followed the economic rocket upward. For a few years, it seemed to be the "best of times."

Then came financial trouble. In 1971–72, Burton Block, stretched to meet a fast-growing demand, was operating on fixed contracts with oil tripling in price and interest rates climbing. The big developers, especially Sea Pines, couldn't pay their bills and Burton Block couldn't pay its bills either.

And in politics

Chairman for a time of the Beaufort County Development Commission, Henry found himself frustrated. He decided to run for mayor of Beaufort, he said, in order to "polish the gem" of the city and thus spur economic

development in the region. Serving as mayor of Beaufort from 1970 to 1991, then, further complicated Henry's life and challenged him on the principle his grandfather had taught him about taking a risk. Like his grandfather, who had befriended political leaders in order to help Beaufort in the 1930s, Henry befriended political leaders—U.S. Senators Strom Thurmond and Fritz Hollings—to get federal dollars to help Beaufort in the 1970s and '80s. He pulled and pushed his rundown hometown, trying with others to move it into the twentieth century:

> To convert the gravity-fed sewer system emptying into the Beaufort River into a modern system with a treatment plant.
> To get rid of outhouses.
> To clean up the Beaufort waterfront and build a public park there.
> To stop the toilets in the stores on Bay Street from discharging directly into the river.
> To become a National Historic District.

For a while Henry lobbied the congressional delegation and the federal agencies in Washington a couple of times a month. On weekends, on Boy Scout camping trips with one of his fellow council members, he not only did his Scout mastering, he also made his pitch for political support for what he wanted to see in Beaufort.

"All of that probably affected Burton Block, but it was just all a part of what I was doing," Henry said.

Eventually, Henry sold one portion of Burton Block to a couple from Ohio and another to Russell Jeter, "basically to take over the debts," he said. In 1980, he went to work for his uncle, owner of Beaufort Realty, and he bought the business the next year.

Eventually, as well, Henry's infrastructure dreams for his hometown came to pass. Building what became the Henry C. Chambers Waterfront Park was the hardest task, requiring the most creativity and the most money. Nationally acclaimed landscape architect Robert Marvin of Walterboro took charge of the design. Clemson's architectural students worked with him. "The public loved the drawings they saw," Henry said, "but everybody was a little afraid of the cost. As the project moved along and payments came due, I would know about commitments I had for grants, but sometimes I could not reveal everything I'd been promised. It was touch and go sometimes. The county council would not help

financially. Port Royal had very little money. The City of Beaufort had to become the leader."

At last, the historic preservation movement together with the waterfront park sparked the rejuvenation of downtown Beaufort. In addition, as real estate values climbed across the region, Henry's friend Sumner Pingree asked him to take over sales as Bray's Island developed. Henry Chambers became a major player for a second time in Beaufort County's growth. Henry continued to negotiate, to put deals together to benefit his clients—and benefit his own net worth.

OVERCOMING PERSONAL TRAGEDIES

By the time of Henry's eighth decade, he could look back on what might be considered more than his share of personal heartaches. Henry and Betty's first son died young in the hospital after a freak accident. Another son suffered a spinal injury in a soccer game, spent much of his adult life in a wheelchair and also died young. Equine encephalitis caused by a mosquito bite during Hurricane Hugo in 1989 plagued Betty for thirteen years, confining her to home and in bed for much of that period, before she died.

As the sources of pain thrust themselves into his life, Henry grieved—and created various support systems. As an adult, he was able, he said, to draw on lessons he had learned as a child. "Pain about the people you love is like a sharp cut that never goes away," he said. "It does, fortunately, get duller with time. I have lived with pain by working twelve to fourteen hours a day at things that have meant a lot to me and to the community.

"Actually, with all of that, I've had a great life," he added. "I've done so much of what I've wanted to do. Betty and I would be off to London, off to the Bahamas. We had great children and wonderful friends."

Even while just starting physical therapy after heart surgery, Henry Chambers continued to negotiate real estate deals; plan a 250th anniversary celebration of Masonry in the Lowcountry; hunt ducks; go fishing in Costa Rica and plan a hunting trip to Africa. A member of half a dozen history-oriented organizations, he continued to research and organize his family files. His daughter, Julia, had family in Wilmington, North Carolina, but also had a house two doors down from Henry's. His son Bill was a Beaufort architect. His daughter Carroll lived in Spartanburg.

In his home overlooking the Beaufort River, Henry treasured his memorabilia, family photographs, framed documents and keepsakes,

antiques, gun collection, artifacts linked to his ancestors: the old Guerard family dining room table, which seated twenty-four for Thanksgiving, the hunting horn of his Uncle Jake Guerard, Bluffton's early twentieth-century dentist.

In the spring of 2006, just off Bay Street in downtown Beaufort, the Henry Chambers Waterfront Park was in the thick of a massive spruce-up.

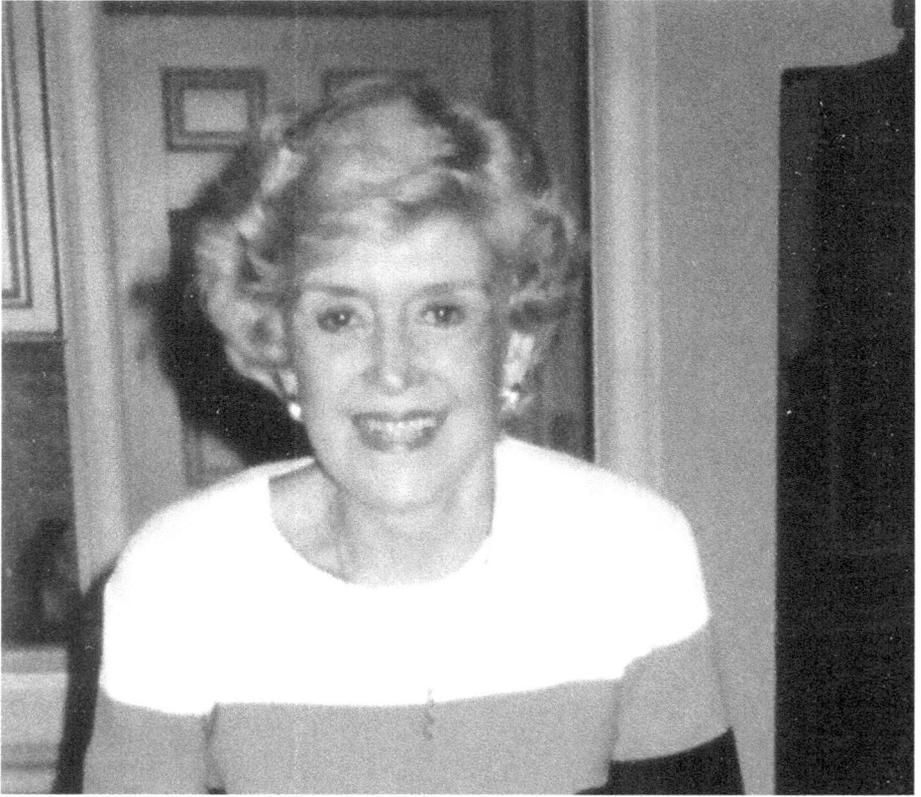

Fran Bass. *Courtesy of Fran Bass.*

STORIES, SONGS AND MOONLIGHT SWIMS

Frances Varn Bass
born 1929

Fran remembered her grandfather, wearing jodhpurs and a white shirt and bow tie, taking her to the lettuce fields.

Growing up in the low-tech Lowcountry, Frances Varn found entertainment free and pleasure an everyday occurrence. The characters in her childhood amused themselves.

A baby of the 1930s, she was just a girl in a Buster Brown haircut when her family, with three children, and another family spent a month in an Edisto Island beach cottage. The comic strip "Popeye" provided the theme for the month. For every conversation, no matter what was going on, everybody was supposed to play one of the Popeye characters. Although the weeklong drama didn't cost a dime, the fun of it stuck in Frances's mind for more than half a century.

Beaufort summers were something to remember anyway: "On full moons on summer nights, Daddy would round us up with all our friends and take us swimming in the Beaufort River off The Point, at a place we called 'the ferry.' It was where people ferried across to Lady's Island. I remember the phosphorous sparkling with every splash, and we would see eels coming to the top."

Why eels, which typically hang out on the river bottoms, would surface during full moons was not something the frolicking swimmers worried about.

Looking back, Fran Varn Bass remembered worrying very little as a child. She mostly remembered fun. She remembered a postcard picture of Charleston's new Cooper River Bridge. It opened in 1929. The bridge's roadbed, a tall, smooth arch, was topped by a steel superstructure, a scalloped affair that looked to young Frances like a roller coaster.

"Daddy made a big deal of taking us to Charleston to ride over the new bridge. I thought we would be going up and down over the top of the whole thing. After we did it, I was so disappointed. I asked him if we could go over it a second time, please, and this time ride on the top. I just knew that would have been more fun."

Raising lettuce and counting tax revenue

Fran's grandfather on her father's side was a part of the Varn family for whom the nearby town of Varnville was named. An entrepreneur as well as a farmer, John Wingate Varn wanted to take advantage of the prospering river-phosphate mining industry in the Coosaw River. After moving to Lady's Island when where was no doctor there—and no bridge to Beaufort—Fran's grandparents lost a little daughter, Rena, to flu. They decided they had better move into town.

Fran remembered her grandfather, wearing jodhpurs and a white shirt and bow tie, taking her to the lettuce fields. "He would take out a clean white handkerchief to wipe the sand off a leaf of lettuce and invite us to take a bite. 'Isn't it wonderful?' he would say." Why did he wear a bow tie to the lettuce fields? "I don't know, but that is just how I remember him."

Winter lettuce played a role in the life of John Wingate Varn's son, Rivers Varn, Fran's father. After graduating from Clemson College, Rivers farmed in northern Beaufort County for a short time before finding out from the local bank that there was no money to borrow to put in the next crop of lettuce. He managed, with his father, to continue to plant crops for a while longer, but he also ran for treasurer of Beaufort County in 1927, hoping to get a government-paying job, just in case. He won that race and afterward had little or no opposition for office until he retired in 1963.

Frances's grandmother on her mother's side graduated in the first class of South Carolina's Winthrop College. A few years after that, her daughter, also a Winthrop graduate, moved from Augusta, Georgia, to

Beaufort to teach first grade. The family story is that Eleanor Hook, the teacher, and Rivers Varn, the farmer, met at a wedding, after which Eleanor put a piece of wedding cake under her pillow in the hopes of dreaming of the man she would marry. She must have dreamed of Rivers. Romance blossomed. They wed soon afterward. Fran was the middle of their three children.

The Varn family lived at 207 Laurens Street in a house that had been built originally on Coosaw Island. Sometime in the early twentieth century it was moved from Coosaw, first by barge down the Beaufort River and then, presumably on high tide, was transferred to palmetto logs and thus rolled inch by inch to the site. Early in the twenty-first century it sold for $1.7 million.

RIVERS AND MUSIC

"The best thing about living in Beaufort as a child was the freedom, and, of course, the rivers," Fran said, having given a few seconds to think about the question. "Rivers" to Frances Varn Bass meant the waters she swam and played in endlessly as a young girl—and also is the given name of her father, the late Rivers Varn, county treasurer for thirty-six years; of her brother, Rivers Varn Jr. of West Virginia, and of her son, Rivers McIntosh of Atlanta, called Lawton. You couldn't say "rivers" around Fran without evoking a memory, a story and a smile. Rowing across the Beaufort River was no big deal to her when she was a mere slip of a girl.

Along with rivers and farming and the county's treasury, music jockeyed constantly for a place in the Varn household. There everybody was expected to play an instrument or two and to sing. Starting with the Clemson Glee Club, her father sang solos in church and for weddings and other occasions the rest of his life.

One story about Fran's father and his music that became a piece of family lore went like this (in Fran's words):

"My father, Rivers Varn, and his friend John Marscher drove together to New York to sell their lettuce crop to whichever buyer would offer the best price. Daddy called their negotiations 'bartering.' They did quite well and went to a nightclub to celebrate.

"After a time, John walked up to the piano player and said, 'I've got a friend with me from South Carolina who sings much better than

anyone we've heard tonight.' With that, Dad was asked to sing the for the nightclub audience.

"Upon returning home, Dad started telling Mom all about their trip and how John had gotten him to sing in the nightclub. He started singing 'I'll be loving you always' and told her of how the piano player had asked him to stay in New York and help promote his songs, including the one that would become the classic 'Always.'

"Mom asked Dad if he knew the piano player's name and added, 'Could it have been Irving Berlin?'

"'Yes,' Dad said, 'they did call him Berlin. I told him I couldn't stay and sing with him because I had to go home and farm.'"

So he did come back to Beaufort to farm, to serve as county treasurer and to sing.

RACE MATTERED

As the stories of both black and white Lowcountry characters illustrate, whites and blacks lived together in Beaufort in close physical proximity but in different worlds in the first half of the twentieth century. Blacks cooked in whites' kitchens, tended whites' gardens and cared for white children but always came to the back door of whites' homes. Fran said she knew even as a young girl born into the thoroughly entrenched Jim Crow system that something was wrong with it. "In our family, we couldn't say 'nigger' any more than we could have said 'ain't,' but we weren't allowed to call a black woman a 'lady' either. It was so insulting to them. The black woman who didn't have a clothesline but hung her laundry out on fig trees had a dignity that should have been respected.

"When I was home from college one time, I saw the black 'yard man' who had worked for my family for years. He was standing on the sidewalk with other black men, and I ran up to him and hugged him. It was only natural for me, but he pushed me away. Clearly, in his mind, it was the wrong thing to do in that place at that time—me, a young white girl hugging a black man."

Fran majored in psychology and sociology at Furman University, and with her first husband raised four children in Anderson, South Carolina. Shortly after Fran and her second husband retired to Hilton Head Plantation, his death knocked a lot of joy out of her life. The new support network she developed came together slowly, and when it did it closely resembled the network of her childhood. Along with her Hilton Head friends, longtime

Beaufort friends, friends from the good old days of low-tech amusement, became more important than ever to her.

"Thank goodness for Ting [Sams Colquhoun]," she said one morning near the end of the twentieth century. "Ting and I go back forever. Just the other day we talked about something that happened when we were children. Even after our family had a refrigerator, hers had an icebox, so the iceman would come a couple of times a week. He would chip an icicle off his big block of ice for us to suck on. That was a cheap thrill for you."

Early in the twenty-first century, Fran was living again among the familiar faces and landscapes of lovely Beaufort. Among the lucky sometimes she would tell stories about the days of long ago.

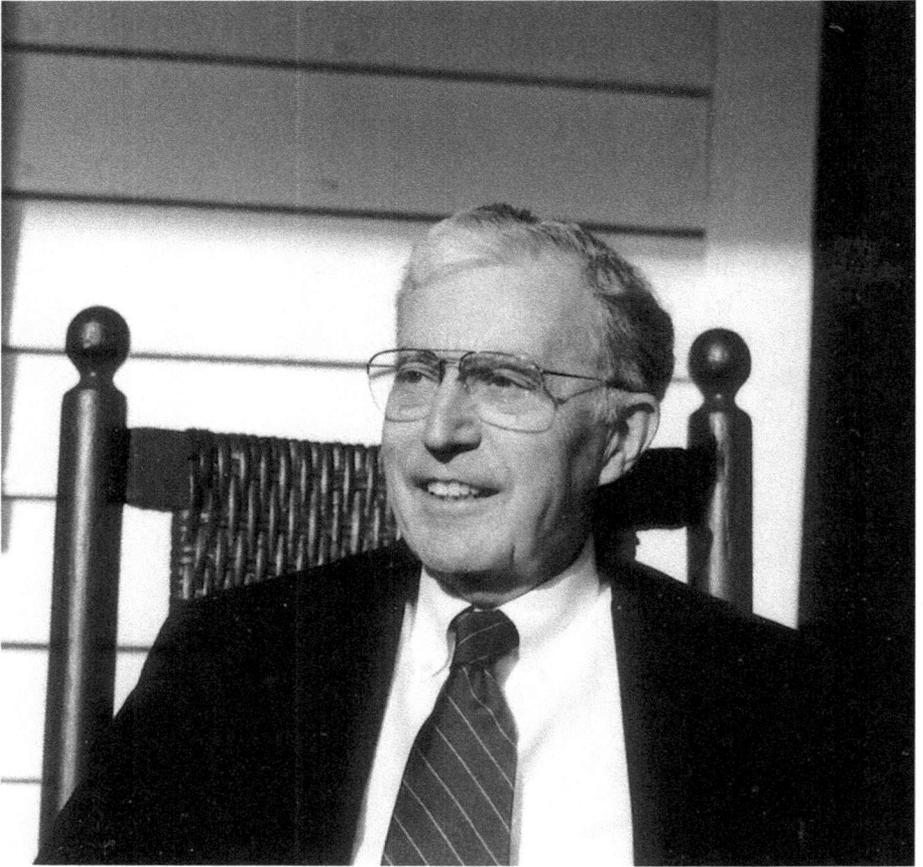

Wyatt Pringle. *Courtesy of Sally Pringle.*

Preservation as Progress

Wyatt Browning Pringle
born 1929

Out camping on one of the islands, the Beaufort boys felt jaunty after drinking strong sassafras tea.

Wyatt and Sally Pringle hosted Beaufort High School's class of 1946's fiftieth reunion in a beautiful, historic—even glamorous—location: their three-story home on The Point. In the midst of all that shared history of old Beaufort, the air was filled with warm exchanges, shrieks of laughter and moments of sorrow and tears. As a boy, Wyatt had been one of the players in the sandbar tales and movie anecdotes his fiftieth reunion guests recalled. As a man, he had been one of the "old Beaufort" leaders who helped knit the old and new threads running through the community into a pleasing tapestry.

Wyatt looked people in the eye when he was in conversation with them. He made his listeners feel important, worthy of his attention. He saw talent in everybody and obviously wanted to learn from people. He also wanted to discern just what whomever he was talking to might do to participate more fully in the community. For several decades, Wyatt embraced Beaufort's newcomers as untapped skill and energy that might help with historic preservation and other causes he held dear.

Wyatt's business was insurance, but his life was built around his family and around his passion for local history, local archeology and genealogy. "He could," said his son, "upon learning your last name, if you were from South Carolina, give a pretty good guess as to which town you were from.

He would know, maybe, something about your cousins, too, or some other family linked to yours by marriage. He started out doing research on the Pringles, back to the 1600s, and he just learned about other families along the way. He was interested in how families fit together, and he could remember all the details, too."

Among the most fun Wyatt and Sally's children had growing up were the local excursions Wyatt led them on to hunt artifacts. Every discovery of a pottery shard, an arrowhead or an old bottle was a cause for celebration. Among the additional values they got from their father was the appreciation of the Lowcountry's natural vegetation. "It pained him," Wyatt Jr. said, "to see people bulldoze sparkleberries and shrub palmettos. He really believed it was important to preserve the indigenous fauna."

By the time I interviewed Wyatt at the end of 2005 he had come to view with serenity the low points and high points of his own life—along with the peaks and valleys representing the well-being of those who call the flat Lowcountry "home." "There are always ups and downs, and we just have to work our way through them," he said. Then he told how his family history, intertwined with the economic history of the region, illustrates that theme.

THE DEPRESSION YEARS

Early in the twentieth century, Wyatt's grandfather enjoyed prosperity as a prominent wholesale merchant in Charleston. Unfortunately, hastened along by the boll weevil and a worldwide drop in cotton prices, the Great Depression arrived early in South Carolina. When the Charleston merchant's son, Somers Pringle, and his fiancée, Kathryn Browning of Blackville, wanted to get married, "There was little money to get married on," Wyatt said. Nevertheless, after a two-year engagement, they wed and moved in with Kathryn's parents in Blackville. Somers took a job with Kathryn's father, traveling across the country by train, selling clothing wholesale, earning a right meager income.

After Somers and Kathryn had two little boys—Somers Jr., born in 1925, and Wyatt, born in 1929—the polio epidemic hit Blackville. Both boys and many of their cousins fell victim to the dreaded disease. Wyatt, the three-year-old, suffered temporarily from paralysis of one leg although he eventually regained its full use, but his brother died of polio at the age of seven. Late in life, Wyatt remembered long lines of black cars at the funeral. He remembered keenly the traumatic impact of that death on his parents.

"My brother had died, so there were 'locks' on me as I was growing up—to protect me from everything," Wyatt said many years later.

In 1935, Wyatt's father got a new job helping in the start of the first public health department in Beaufort County. As sanitarian, he initiated a project of building privies for families without running water or toilets. The hope was to eradicate worms in the human population and curtail diseases overall. In addition, as inspector of the county's numerous oyster factories, Somers traveled the creeks and sounds by boat to make sure the shucking and steaming and packing of oysters was handled in a sanitary manner.

Somers was not always welcomed in the oyster factories. The toilets, the water supplies, the places and the processes all had to be kept clean and managed by rules. Typically, those who made a living on seafood liked their isolation on the islands and preferred doing everything their own way. They did not take well to being told by somebody from the health department what they had to do. Every violation he found required action, usually at some expense to the factory owner.

"One oyster factory owner on Hilton Head told my father he'd better not come back or he'd be found dead at the foot of the dock," Wyatt said. "That was not a particularly good day for him."

Living on The Point in Beaufort, the Pringles were surrounded by families with children who had the run of the neighborhood and the run of the Beaufort River for swimming, fishing, rowing, shrimping and crabbing. Often the Beaufort boys packed their small bateaux with camping gear, rowed to various small islands and spent a couple of nights at a time. They felt jaunty after drinking strong sassafras tea. They used tents and built small huts, but the mosquitoes were fierce.

As Wyatt remembers his childhood, "The Point boys did anything they wanted to do. A lot of other parents brought their children to The Point and dropped them off, just as parents today might drop off their children at the Y or somewhere else today." Within walking distance of the Pringle home stood the elementary school Wyatt called "wonderful," staffed by teachers he thought of as "heroes."

In those more provincial times, teachers' living arrangements had to be approved by the school board. Many teachers, mostly single women, lived together in a boardinghouse called the "teacherage." Some boarded with families in the community, and Wyatt's parents would like to have had a teacher board with them. But Kathryn had been raised Catholic and she continued to practice her faith in St. Peter's Catholic Church despite Somers's service as senior warden for St. Helena Episcopal Church. The school board

adopted a policy reflecting the religious bias in place at the time: No public school teacher could live in a home with a practicing Catholic in it.

COLLEGE, WORK AND SERVICE TO COMMUNITY

Wyatt hit what he called a "low period" in his life when he went off to Clemson College (now University), an all-male military institution at the time known for its severe hazing. The upperclassmen were, he said, "unmercifully rough." Getting beaten on the backsides with a paddle, a commercial broom and sabers was not his idea of higher education.

At the end of Wyatt's freshman year, he transferred to The Citadel as a sophomore. There he majored in political science, graduated with honors and soon began what he called a long "high period" of prosperity and contentment. While on a tour of duty in the Army Reserve afterward, as a first lieutenant in Norfolk, Virginia, he met Sally Gray, a girl called both the "nicest" and the "prettiest" in Norfolk. After a two-year courtship, Wyatt and Sally married in 1955 and moved to Beaufort.

An eleven-week training program for Travelers Insurance in Hartford, Connecticut, prepared Wyatt for a career in insurance. He worked briefly for Travelers in Charlotte before being hired by his old scoutmaster to work for Kinghorn Insurance Co., a Beaufort agency established in 1898. During the next forty years at Kinghorn, eventually as the senior partner, Wyatt carefully grew the business as the region's population grew. Under Wyatt's leadership, Kinghorn's annual premiums climbed from $85,000 to $25 million. Sally said he built the business on the basis of his honesty: "People trusted him." His parent-induced habit of considering the risk when undertaking a venture also may have been a factor.

Three children came along over the years—Katherine, Wyatt Jr. and Frances—and so did leadership in many community organizations. Together, Wyatt and Sally were recognized for their significant service to Historic Beaufort Foundation. Active in St. Peter's Catholic Church, Wyatt was honored by Pope John Paul II by being named a Knight Commander of the Order of Saint Gregory the Great. He was one of the original founders of the Beaufort Water Festival, an event he loved because it celebrated what he called the best part of being in Beaufort: the water.

Wyatt's twelve years on the Beaufort County Board of Education included the stressful period of racial segregation, racial anxieties and racial integration. Although consolidation of black schools and white schools in Beaufort County went through peacefully in 1970, Wyatt had an insurance client who felt

obligated to express her outrage at his leadership role in the matter. "One lady brought the insurance policies she had with me and threw them in my face," he said. Wyatt was confident he was doing the right thing, but like the day the oysterman threatened his father, that day was not a good one for Wyatt.

THE CHRISTENSEN/PRINGLE HOUSE

Wyatt and Sally's home of several decades reflected their love of local history. They bought the big double-porch Christensen house sitting on two acres overlooking the Beaufort River for about $65,000 in an auction at the courthouse steps in the fall of 1974. A few years earlier it and others like it might have been bought for less than $15,000. Exactly when the house was built they didn't know, but they had records showing it existed in 1840. A Methodist missionary who came to Beaufort to evangelize the slaves, Thomas E. Ledbetter, signed the marl tiles in the fireplaces and the lathing behind the plaster walls.

"The house was in poor condition," Sally said about what they bought. Nevertheless, by the spring of 1977 the house had been restored to its former glory and the Pringles moved in. Despite requirements for incessant restoration and maintenance, the house became a constant source of pride and joy and an excellent investment. By 2006, similar properties were selling for several million dollars.

Early in the twenty-first century, Wyatt was enjoying a good life in the neighborhood of his childhood, surrounded by family, including four grandchildren, and by friends, when he was diagnosed with a tumor at the base of his brain. Despite some of the best medical treatment available, which relieved his suffering, he did not recover fully.

When I interviewed Wyatt, he found speech difficult. He tired easily. He said to me, "This is a low point in my life." Wyatt Pringle, nevertheless, with Sally as a prompter, searched back more than seventy years into his memory, describing candidly not only what happened in Beaufort but also how he felt about what happened. Through the insurance business, he and Sally had traveled widely, but neither his heart nor his home had ever really left the South Carolina Lowcountry. Recalling the way it was long ago in Beaufort—and believing that some of the best memories of his own past were being preserved in this story—gave him a lift.

It also made him realize, he said, "How lucky I am to have lived in the wonderful little town that Beaufort still is today."

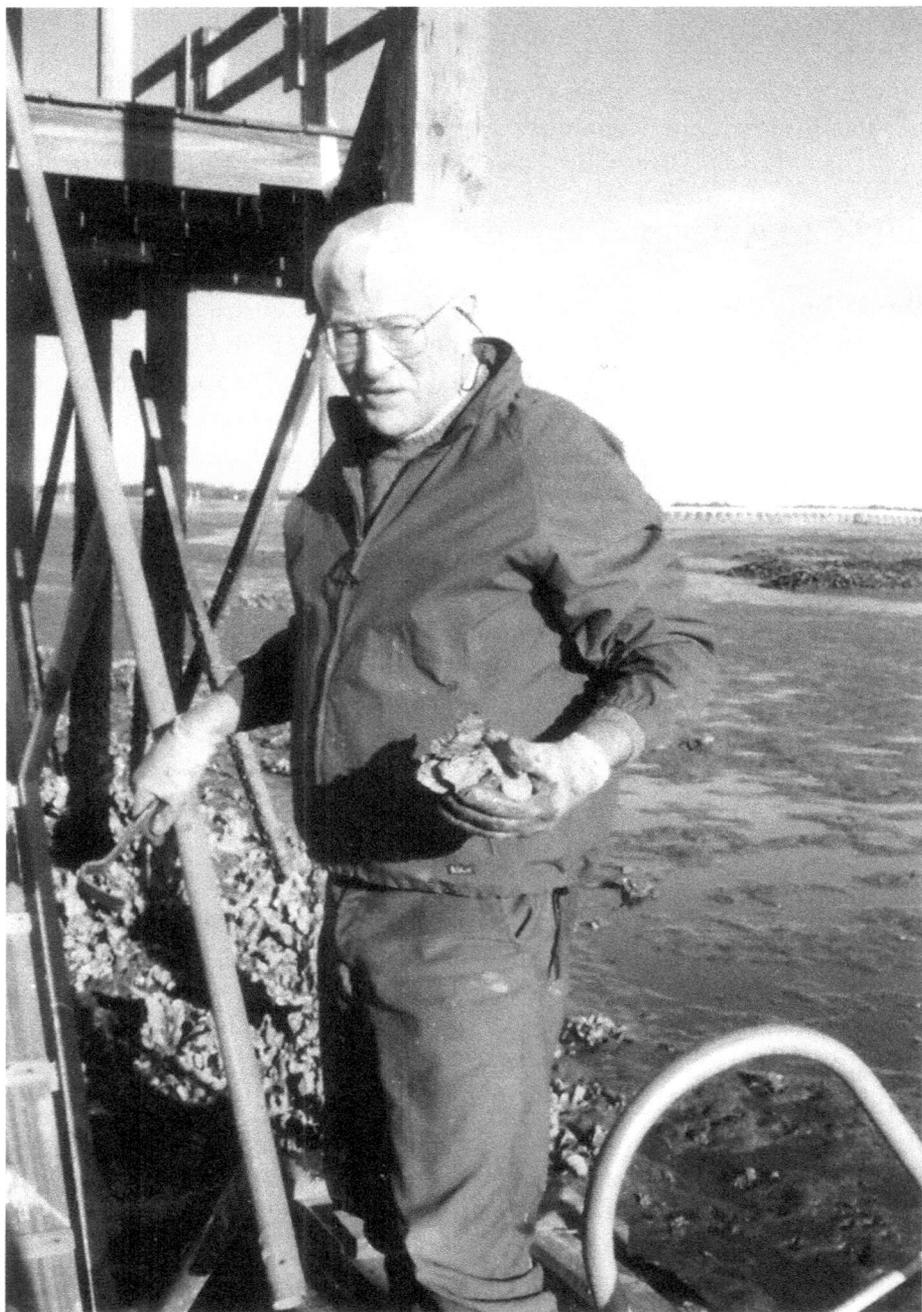

William F. "Bill" Marscher II.

CONFIDENCE AND PATIENCE PAID OFF

William Frederick "Bill" Marscher II born 1929

"MIT was an amazing place for a boy from Beaufort."

"Billy Goat Marshmallow" he was called, blond, blue-eyed, tall for his age, quick to tease and quicker to laugh but conscientious about matters of consequence.

When he was twelve, he bought an old 1.5-horsepower outboard engine for fifteen dollars. It wasn't running at the time, but he knew just enough about engines to get it going. He put it on an old twelve-foot bateau he had found in the Beaufort River marsh. Soon he and his friends were cruising the creeks and camping on Goat Island. "If we had the tide with us, we could move along pretty well," he said. "It beat rowing." At fourteen, at the height of World War II's gasoline rationing, he bought a used Model A Ford with flat tires. It also was not running at the time. "We fixed the tires and towed it home. I knew a little about motors. I went down and talked to the Ford people at Horne Motor Co. I was able to get it running. I would siphon a little gasoline out of Daddy's car. Also, on a long trip, maybe from Beaufort to the tomato-packing shed on St. Helena, where some of my friends and I worked one summer, I could switch to kerosene for a few miles to save gas."

Later, at the time in one's life when one looks back and tries to summarize, William Frederick "Bill" Marscher II would credit his father

with teaching him to have as much fun as possible fishing in the surf of Fripp, Hunting and Pritchards Islands and hunting quail and dove all over Beaufort County; would credit his mother with pushing him toward excellence. He had a fortuitous childhood in Beaufort, he said, growing up where most people knew one another and where it was easier most of the time to do what was right. Something along the way gave him confidence, self-esteem, the assurance that he could do whatever he made up his mind to do. "It's also patience that I have," he said. "Not that I'm so smart. I just don't give up."

Maybe Bill's perseverance in matters such as repairing engines others had abandoned came from his father's German ancestors, Marschers and Schepers. His grandfather William Frederick Marscher and his grandmother Johanna Mathilde Wilheline Cather Scheper Marscher, called "Dearie," were both part of the second generation of Americans whose parents emigrated from Germany in the mid-1800s. Their parents had seen opportunity in the late nineteenth-century river-phosphate industry thriving in the Coosaw River. The hurricane of 1893 wiped out the phosphate mining fleet and thus ended that rare source of cash in Beaufort's economy, but the truck farming that came along early in the twentieth century soon was a big enough business to support a bank. So the Marschers and Schepers stayed in Beaufort and eventually prospered, as much as anyone could have prospered in the South Carolina Lowcountry in those years.

Bill's father, Arthur, was born in Beaufort in 1900, when Beaufort County's white community was quite small, only about 10 percent of the county's population of about thirty-five thousand. Arthur was tutored at home before going to Clemson College and majoring in dairy farming.

Or maybe Bill's trait of persistence, also called stubbornness, may have come from his mother's Scotch-Irish ancestors, Watsons and Dorsets. His mother, Gladys Watson, whose family had settled in the interior of the Carolinas in the 1700s, grew up in Columbia in a family of eight children and was the first in her family to graduate from college. She earned a degree from Winthrop before taking a job in Beaufort teaching high school math.

In that small city of Beaufort, it was easy enough for a young dairy farmer and a young math teacher to meet and fall in love. Arthur and Gladys were married in 1928.

Billy was born on November 3, 1929, four days after the stock market crash preceding the Great Depression. Arthur Jr. came along seven years later. At one point, Arthur Sr. left the dairy farm to work in the

insurance business. Then he ran the Beaufort office of the Farm Security Administration, a New Deal program of the 1930s. In the 1940s Arthur became a sanitarian for the public health department.

"My family never had much money in those days," Bill said, "but Daddy always had a job, and since most of my friends and my parents' friends were in the same boat as my family, we didn't know we were poor."

LOWCOUNTRY TRADITIONS

Along with "Mammy and Daddy" and school, Boy Scouts and St. Helena's Episcopal Church provided most of the guidance and the cultural enrichment for young Billy. As an acolyte at St. Helena's, where his parents and grandparents had "their pews," he memorized liturgies from the 1928 *Book of Common Prayer*. In church services many decades later, he occasionally continued to speak the old prayer book language out of habit, having never gotten over the 1977 revisions. Summers he often was sent to Kanuga, the Episcopal church camp near Hendersonville, North Carolina. As an adult, Bill often walked reverently through the church cemetery, paying respects to his forefathers and foremothers, Schepers and Marschers. Scouting helped round him out. Bill's lifelong affection for bird watching and for woodcraft evolved out of Scouting, including especially his regular summer camping sessions at Camp Ho-Non-Wah on Wadmalaw Island. By the age of fourteen, he had become an Eagle Scout, an achievement that warranted pride and a framed certificate on his office wall more than sixty years later.

Whether boggin' or swimmin', fishin' or shimpin', it was always "the river" that entertained the children of old Beaufort, and "going down the river" became a unique Beaufort-only adventure. For several summers in a row, three women (Gladys Marscher, Margaret Scheper and Lucille McTeer) and their seven children (Billy and Arthur Marscher, Willie and Margaret Shep Scheper and Georgianna, Mookie and Ed McTeer) with two cooks and a captain took the sixty-five-foot houseboat *Owanee* from Beaufort to Skull Inlet. Except for the seafood they would catch, and loggerhead turtle eggs, they had to take every bite to eat and every sip to drink. They carried a three hundred-pound block of ice in the onboard icebox.

With the boat safely anchored between Fripp and Pritchard Islands for a couple of weeks, the adventurers walked the beaches and gazed at the horizon; hunted for driftwood and other flotsam and jetsam; dug turtle eggs; went surf fishing and swimming. "It was a vacation sent from

heaven," Bill said. "The *Owanee* belonged to the bank, but lots of people used it. The only thing we had to worry about when we went 'down the river' was deciding what to do next for recreation. Those of us who went 'down the river' that way will never forget those days."

One summer between high school years he worked as a rodman for surveyors on Parris Island, keenly aware of the surveyor's rare privilege of going into the women reserve area of the base. It was, he said, "revealing." Another summer he accidentally found old newspapers with stories about the devastating 1893 hurricane that hit the Lowcountry; that discovery propelled him into a lifetime search for more information and eventually led to writing a book about it. Another summer he and Brantley Harvey launched a small commercial crabbing operation. Later, he worked as a carpenter's apprentice on construction of the Naval Hospital.

As a Beaufort High School junior, Billy was a part of two state championships, one in basketball and one in football. Since there was no twelfth grade at the time, at the age of fifteen, in 1946, following the steps of his father, his Uncle John, his Uncle Flip and his Great Uncle Will, he was off to Clemson College. Most of his fellow freshmen were from South Carolina, all quite "green behind the ears," he said, having had very little exposure to the world. Fortunately, by then, Clemson had taken in hundreds of returning World War II veterans for education under the G.I. Bill and the young college freshmen found themselves surrounded by quite serious, older students. "We didn't realize it, of course, but just being in classes with those G.I.'s taught us a lot we wouldn't have learned otherwise."

Among the surprises from the Clemson experience, Bill landed in "Doc" Taylor's class on Victorian literature. He came to revel in "The Rime of the Ancient Mariner" and "Ode to a Grecian Urn" and later found himself a lifelong fan of Wordsworth, Coleridge, Shelley, Keats, Browning and other Romantic poets. Later, his grandchildren might be surprised to find out he hitchhiked from Clemson home to Beaufort for Thanksgiving and Christmas, but that's how college students traveled in those days. "We would just stand out on the road near the library in our Clemson uniforms and stick out our thumbs. You could go almost anywhere that way," Bill said.

Except for ROTC camp, summers between the college years Bill spent back in Beaufort, working in the Sanders family's tomato-packing sheds on St. Helena Island.

Young engineer

In 1950, with a fresh BS in mechanical engineering, Bill became an engineer-in-training for General Electric. In Erie, Pennsylvania, he worked on the design of locomotives and refrigerators and lived and socialized with other engineers. Transferred then to Cincinnati, he found a Beaufort buddy for a roommate, C.H. "Sonny" Von Harten. Then he transferred to Lynn, Massachusetts, where he and two others rented an oceanfront house in Marblehead.

Professional and personal successes came quickly in those years. Bill designed a fuel control for a jet engine for which he obtained a U.S. patent. He married Adrienne Kennedy of West Hartford, Connecticut, and started a family. He began sailing competitively in Marblehead and snow skiing. He found Boston fascinating. Next, GE offered him an opportunity to go to the Massachusetts Institute of Technology (MIT) on full salary to earn a master's degree. Then he transferred to GE Philadelphia to help prepare a proposal for design of a portion of the *Apollo* spacecraft, the one to take the United States to the moon and back. After MIT was selected instead of GE for the *Apollo* work, MIT hired Bill. He became a part of the team responsible for designing the onboard guidance and navigation system of *Apollo*'s command and lunar landing modules—and for training the astronauts to use them.

"MIT was an amazing place for a boy from Beaufort," Bill said. "The attitude permeated the place that nothing was impossible. I was around really brilliant people, scientists, engineers, astronauts. Looking back, I'm not sure I realized at the time how fortunate I was."

Later, he realized that for him, the most exciting achievement was the first successful manned circumlunar flight: to the moon, around the moon and back to Earth. "When the module was on the backside of the moon, there was no contact, and we all were very tense. When it came out again and we were in touch with the astronaut, we all whooped for joy," he said.

Once Neil Armstrong had taken the famous "step for mankind" on the moon in 1969, Bill Marscher found himself considering how he might get back to the Lowcountry to live. Sea Pines founder Charles Fraser, on a binge of hiring from the Ivy League universities, took him on as vice-president for leisure systems. Harbour Town at the time was, as Bill described it, "just a pile of dirt." One of his responsibilities for Sea Pines was to help start Sea Pines Academy (which became Hilton Head Preparatory School). The family bought a house on Calibogue Cay in Sea Pines. Suddenly, in part because of his local knowledge, Bill became the

point man for Sea Pines in Hilton Head Islanders' fierce campaign to stop a German chemical manufacturer, BASF, from building a plant on the Colleton River. It was a fight he relished, his first full-blown plunge into environmental controversy. "I knew nothing about politics, really. Boy, did I have to learn," he said. It was an experience that helped prepare him for a future "career" as a volunteer strategizing in public policy.

At Sea Pines in the early 1970s, once the school had been launched and the chemical plant had backed off its plans, Bill was ready to move on to the next phase of his life. The can-do spirit of MIT held strong when he bought Rose Supply, a plumbing and electrical supply business in Beaufort, and opened a second store on Hilton Head Island. Now the task was to learn how to run a business; to learn all about pipe and fixtures, switches and wires; to make sure the markups were right, make sure the plumbers and electricians who were his customers paid their bills on time and in full.

"All my life I've had to keep learning," Bill said. "With Rose Supply I had to learn that the plumbers are the last subcontractors to get paid for a construction project. If the project got in trouble, the plumbers would have trouble collecting and would have trouble paying Rose Supply. I had to get strict with credit. Also, I had fierce competition because the bigger supply businesses could buy at large discounts. Fortunately after about ten years I was able to sell to a competitor, keep the commercial property and develop a rental income as a result."

Bill took commercial real estate courses and got into the real estate business but found his next calling elsewhere.

Varied public service

Intrigued by the possibilities for the Town of Hilton Head Island, incorporated in 1983, he served as mayor pro tempore on the second and third terms of Town Council. Those were the heady days of writing the Land Management Ordinance, working on permits and money for the first beach nourishment and pushing forward the real estate transfer fee, finally adopted after he left office. In a three-way race for mayor he came in second. "I guess I was lucky," he said, laughing, as he looked around happily for other opportunities.

Just as he assumed at the age of fourteen he could repair a Model A Ford despite never having done it, he assumed more than fifty years later he could handle other new projects. He volunteered to work on an operational

audit for Beaufort County Council and was elected chairman of the audit committee of thirty-five. At the request of the Beaufort County School District, he chaired the Oversight Committee charged with reporting to the public on the construction projects resulting from the $120 million 1995 bond referendum. When storm water polluted the oyster beds in Broad Creek and the Okatie River, he started the Clean Water Task Force to determine what could be done about that. Out of that last effort evolved a wave of new initiatives aimed at protecting local waters from the ravages of development.

Early in the twenty-first century the boy called "Billy Goat Marshmallow," tall, slim and blue-eyed, had snow-white hair. He was still quick to tease and quicker to laugh—"like his dad," everybody said—but still conscientious about matters of consequence. By then, he had co-authored two books with his second wife, *Living in the Danger Zone: Realities about Hurricanes* and *The Great Sea Island Storm of 1893*. He had put his carpentry skills to work building a dock on Mackays Creek (everything but the pilings), developed a year-round vegetable garden and come to enjoy international home exchanging and a Great Books Discussion Group.

The boy born in Beaufort four days after the stock market crash of 1929 had done all right. He was proud of his two children, William Frederick "Rick" Marscher III of Hilton Head Island and Carolyn Marscher Trenda of Maryville, Tennessee, and four grandchildren. He felt like a rich man.

Robert "Bobby" Middleton.

"DOUBLY BLESSED," HE SAID

Robert "Bobby" Middleton born 1929

Jim Middleton taught Bobby how to grow food and harvest food from the creeks, how to knit cast nets out of cotton twine, how to build a bateau.

From house to house in the fall of the 1930s and '40s, Jim Middleton would travel with his horse and wagon, handing out hams and bacon, ribs and loins. He had butchered three or four hogs and was sharing with the neighbors.

"My father never charged nobody nothing for hog meat," Robert "Bobby" Middleton said simply. "He believed that if he gave with one hand he would receive with the other, and it worked for him. He shared beans or fish and whatever he had on any given day. But he was never short of what he gave away because everybody on St. Helena Island looked after one another in that same way. Everybody shared what we had."

The ways of St. Helena in his youth were good traditions, Bobby said, adding that the people lived together on that remote sea island like a family. "Everybody old enough had respect," he said. "If a person was an adult, as a child, you were expected to show respect to that person at all times, to obey that person if you were told something to do. If any older person gave you direction it was the same as having your parents give direction."

Amid feelings of confidence that no one would steal another's belongings, doors were left unlocked. "If anyone needed to borrow something, he

could borrow it from whoever had it, so nobody needed to steal anything," Bobby explained, laughing. "We trusted one another. And if there was a misunderstanding, we all believed that misunderstanding needed to be settled by sundown. Those who were in dispute with one another were expected to have it together before dark."

For the most part, the leaders of First African Baptist Church and other Christian congregations meted out justice, criminal and civil. Only in serious cases would the sheriff and the courts take charge of matters. Sometimes a judge or an officer would conduct an investigation and then turn all the information over to the deacons and the preacher. It was up to them to apply their common sense and the tenets of their faith to satisfy the community.

Bobby always felt fortunate to grow up where he did and as he did. So he took extraordinary steps to give his own children that same opportunity. Actually, Bobby felt he had an extraordinary life, both on and away from St. Helena. He said he was doubly blessed because of having two sets of loving parents, two mothers and two fathers, all strong on common sense and faith. He liked telling that story and was about to have a book published on his life's story in 2006.

FROM PHILLY TO ST. HELENA

Jim and Addie Middleton, St. Helena Island natives, had gone north to make a living when a young girl living in their Philadelphia neighborhood had a baby out of wedlock in 1929. Jim was working as a longshoreman. Jim and Addie, who had no children, were glad to get the infant to love and to raise as their own. They named him Robert and called him Bobby. For all practical purposes, he was their child, although they never formally adopted him.

The next year Jim and Addie and the toddler Bobby moved back to St. Helena, where more than half a century after the Civil War thousands of former slaves and their descendants lived and worked on the old cotton plantation properties. "After the slave owners left, generation after generation of blacks kept living on Coffin Point, Lands End, Fripp Point, Cedar Grove, Orange Grove and Scotts, all the plantations. They were not really plantations then, but we still called them by their plantation names. There are more of them. And these people living there all knew one another because of church and baseball and everything. We always had fish fries after the baseball games. It was wonderful. They were all

working for themselves, and they owned the land. It was a wonderful, wonderful place," Bobby said.

The only pavement on St. Helena at the time ran on U.S. 21 from the Cowan Creek Bridge to Frogmore, at the intersection with what is now Martin Luther King Boulevard. Every other road was sandy, usually two-rutted with weeds and grass growing between the ruts. There were plenty of footpaths. Nobody cared, Bobby said, if you walked across somebody's yard to get where you wanted to go.

Bobby's father built a house on the Middleton family's ten acres. Bobby felt fortunate that he had a "change of clothes every day for school" and his "own room." For a while a nephew shared the home, but there always seemed to be enough of everything to go around. Jim Middleton believed it essential to teach Bobby how to grow food—typical vegetables and a "little patch of rice"—and how to harvest food from the creeks, how to knit cast nets out of cotton twine, how to build a bateau. "We had to learn those things for survival," Bobby said.

From St. Helena to Philly

For the first six grades of school, Bobby walked three miles down Seaside Road to the Lee Rosenwald School. For the next four grades, he was a Penn School student. In the eleventh grade, Bobby decided he should leave school, feeling he needed to learn to take care of himself. "I needed to learn to survive," he said. Bobby hired out on other farms, then got a job in maintenance on Parris Island. He served two years in the U.S. Army and then went back to work on Parris Island before deciding he could find better financial opportunity in Philadelphia, home of his birth. There he worked in maintenance for restaurants, hotels, banks and for the City of Philadelphia.

One night Bobby dreamed that his biological mother was ill and needed his help. Since he did not know her and had no idea where to find her, he took his story to a newspaper popular in Philadelphia's black communities. The editor ran his photograph. Suddenly, many readers noticed the similarity of the face in the newspaper to a man who ran a bar just down the street from where Bobby was living. On the basis of the photo and of Bobby's description of his adoptive parents, he identified the barman as his biological father and thus met his real mother, by then the barman's wife.

"I was born before my mother and father were married, so my real mother never talked about me until that day. And then suddenly the house was full of people, all of her other children, in-laws and grandchildren.

"So that's how I came to have two sets of parents. Both of them were beautiful. I had good relationships with them and with all of my half-siblings. They were all very loving people, so I have been really fortunate in my life."

Soon after meeting his biological mother and father, Bobby and his wife, Bernice, also of St. Helena originally, decided Philadelphia was a harder place to raise children than St. Helena Island would be. "There was the drug problem and there were crimes, and we felt we should move back home," Bobby said. "Altogether we had seven children. I wouldn't have wanted them raised in Philadelphia at that time."

AND BACK AGAIN

"Back on St. Helena, I found work in the landscaping business. I always loved to see things grow, from the time I was a boy working for my father in the family garden." As Fripp Island and then Dataw Island developed, Bobby had no trouble keeping a job. He got pretty good at planting palmettos, the state tree. "You handle them gently," he said, "so the heart at the top of the tree does not hit the ground hard. That is the most important thing. You cut the fronds back and make a reservoir around the base of the trunk. You keep it watered till it gets roots. If you don't do it right, they'll die on you. If you do it right, you can keep them alive."

By the time Bobby was in his seventies, he was working part-time for the Town of Port Royal's maintenance department, teaching Sunday school and Bible study and serving as a deacon in his church. At Penn Center he volunteered in the York W. Bailey Museum and took visitors around the campus and around St. Helena Island, telling whoever would listen about the old ways of the Lowcountry Gullahs. At every opportunity he offered his philosophy about how to make the world a better place: "This attitude of everybody for himself is not the way," he said. "I learned that from my double set of parents and from growing up on St. Helena. Everything would be better if people had more love."

PERSPECTIVE ON THE BIRTH YEARS
1930–1936

Like much of the South, northern Beaufort County hardly knew the Great Depression was on. Cash had been in short supply since the Civil War ended; scarcity was nothing new. There were a few exports: vegetables and seafood, in season. A few visitors came for winter hunting or mild winter weather. The Marines brought a few fresh new ideas into the mix. And yet, Beaufort and its nearby communities lived in the 1930s pretty much as they had lived in the previous decade, out of the nation's mainstream economy.

The United States had a population of 122 million. Beaufort County had a population of 21,815 in 1930, still predominantly black: 2,831 in the City of Beaufort, 480 in Bluffton, 333 in Port Royal, 323 in Yemassee and the rest scattered over the 702-square-mile area. Sometimes you could travel the dirt and sand and gravel and oyster shell roads from one village to another and not see a soul.

Ross and Martha Sanders.

At home in the tomato fields

Ross Macdonald Sanders
born 1930

Ed's farm-to-market route often was by boat, shipments going out of Station Creek and from a landing on Capers Island to the railroad in Port Royal.

The joke ran around that Ross Sanders, in growing season, told his tomato plants "good morning" first thing every day and "good evening" last thing every night. Thing is it's not a joke.

"You have to look at every field every day," Ross said. "You don't just put those plants in and hope. You nurture them along. And then, oh boy. The demands really start and go on around the clock for about a month. In this business, you just can't party and can't vacation certain times of the year."

Ross knew the tomato-growing business, all right, knew its history, watched its present and worried about its future. License plates on the many vehicles belonging to Ross, his wife Martha, their children and in-laws and grandchildren said: "TOMATO," "TOMATO1," "TOMATO2" and so on up to "TOMATO9," and then on to "1TOMATO," "2TOMATO" and so on.

LETTUCE AND TOMATOES

In the early 1900s, Gustav "Gus" Sanders, Ross's grandfather, who grew up on Running Deer Plantation in the Okatie region south of the Broad

River, planted what was believed to be the first commercial tomato crops on the East Coast. He planted other crops as well, making $130,000 profit, a lot of money in those days, on a lettuce crop on St. Helena one year. Unfortunately, the timing was terrible. Gus put the money in the bank and saw it disappear when the banks crashed during the Great Depression. Gus kept going nevertheless.

Gus and his wife Bessie lived in Port Royal and then in Beaufort, raising a family of eight children. He was a real estate speculator as well as a farmer. As county treasurer for a time, he had a heads-up on property looking for a buyer. He bought and sold property and accumulated property and at one point owned three thousand acres in Beaufort County.

Ed Sanders, one of Gus and Bessie's sons, decided at the age of seventeen to move from Beaufort to live on his father's St. Helena Island farm. Soon he was cultivating a hundred acres of vegetables a year, plowing that sandy soil with mules and depending on the hand labor of St. Helena residents to plant and harvest. Cucumbers and tomatoes, the most profitable crops, grew in spring; broccoli rabe and lettuce in winter. The timing and volume of rainfall was critical. Ed's only irrigation system consisted of pumps that put water in the alleys, but it was a hit-and-miss effort without modern-day laser equipment to level and ground properly so the flooding could work.

Although by 1927 the bridge across the Beaufort River connected St. Helena and Lady's Island with Beaufort, St. Helena's roads still were deep-rutted trails, unsuitable for handling heavy truckloads of packed vegetables. So Ed's farm-to-market route often was by boat, shipments going out of Station Creek and from a landing on Capers Island to the railroad in Port Royal.

As a young eligible bachelor on St. Helena, Ed found a young woman living there with her parents, the entrepreneurial Macdonald family. After he and Margaret "Argie" Macdonald were married, they moved into the Macdonald family home overlooking the marshes of Harbor River, a house now called "Frogmore Manor," formerly the home of Penn School's founders. Their two sons, Ross and Robin, and daughter, Elizabeth "Sibet," grew up there. Their next-door neighbors were the McGowans of the book *The Gullah Mailman*. Most of their other neighbors, the St. Helena population of five to six thousand, were black.

As youngsters, Ross and Robin Sanders were called on to help with the farming and the packing. Tomatoes, the most profitable crop, became

a bigger and bigger portion of his father's harvest every year. Ross said one of his first jobs was delivering the paper to the packers wrapping the tomatoes individually as they laid them in the boxes.

HUNTIN' ON ST. HELENA

"I learned a lot about farming from my daddy, but in those days I was more interested in fishin' and huntin'," Ross said. "All the black people planted little patches of corn and peas, so there was plenty of quail on St. Helena then. I'd go down to the end of the road to catch the school bus but instead of getting on the bus, I'd just wander around the whole island shooting quail some days. It was the life." He laughed.

Ed and Argie didn't go for Ross's preferred casual lifestyle at the time, so they sent him to Stanton Military Academy in Stanton, Virginia, where he graduated from high school after three years. "I stayed at Stanton, but no, I didn't like it at all," Ross said. "I didn't like the military part of Clemson College [now University] when I got there either, and I left Clemson after a short time.

"My daddy got to me after the Clemson exodus, though. He had rented some property in Florida, near Lake Okeechobee, and he sent me down there to plant cucumbers. It was awful. It was worse than Clemson," he said, and he laughed again.

When Ross got back to St. Helena, he settled down a bit and got more seriously into farming with Ed. Gradually they mechanized more and more of the operations and increased the number of acres planted.

As Ross told the story, one day he spotted Martha Graham walking out of Peoples Bank in Beaufort and decided he ought to get to know her. Martha had been a Ridgeland girl until her father died and her mother moved to Beaufort to take the job of hostess for the boardinghouse for teachers, called locally "the teacherage." In 1951 Ross convinced Martha to become a farmer's wife and move to St. Helena with him. With Martha as a partner, he really planted his feet on the ground, so to speak, and set out to make the farm truly profitable.

GROWING SEASONS, GROWING YEARS

Through the 1950s and the 1980s, Ross and Martha functioned as a team in the tomato business. Martha, who had taken a secretarial course from Newberry College, kept up with the money—the huge outlays

before the plants were in the ground, the receipts when the produce hit the market. When they were picking and packing, they would be working as many as two hundred laborers. In the off-season, they would work as many as twenty-five or thirty. Ross took a lot of pride in "never writing a check" himself but depending on Martha for the business end of the operation. Actually, he had plenty else to do. He stayed on top of the year-round production system. He found the value of plastic to control weeds and hold moisture in the soil and shifted from the rainfall-and-hope watering system to plastic drip-irrigation pipes. Through southeastern universities' agricultural research programs, Ross got into more and more specific remedies to counter the various threats to production: fungus, insects, wind, cold, heat and an over-abundance of rain.

As St. Helena's blacks found other opportunities for income—in the county's growing construction and resort industries and with government safety nets—they became less and less available for the seasonal farm work. Ross and Martha turned increasingly to transient labor, crews of migrant Mexicans hired as needed and paid by the "piece work."

While the farm grew, the family grew, too. With the help of Cinda, a young St. Helena woman who rarely if ever left the island, Ross and Martha raised two sons, Gray and Mac, and two daughters, Lea and Caroline. It hardly occurred to Ross that the children wouldn't grow up working on the farm. Gray and Mac were still quite young boys when he put them to work driving tractors. Lea and Caroline started early to help in the office and in the packing shed.

Ross took a scolding from his father one day about making his children work so much. "One day Daddy called me on the farm radio saying he wanted to see me. First, I said I'd be over there in a little while. Then he said, 'No, I want to see you now.' I thought, 'Oh, hell.' But I went. What he wanted to say was that I ought not be working his grandsons to death. He told me even a mule needs to look up and see daylight sometime. It's true Gray and Mac didn't get to play as much as some of their friends."

All four children went to Clemson. When Lea had a college friend come from Clemson to visit the family on St. Helena one weekend, he offered an observation: "In my next life I want to come back as a Sanders. But make that a Sanders girl, not a Sanders boy."

Gus Sanders and later Ed Sanders called the family's original St. Helena Island operation Capers Island Farm. As Ross and his brother Robin began to plan how to pass on their legacy to their separate children, they decided

to divide the property and the operation. Robin's portion became Station Creek Farm. Ross's became Seaside Farm Inc.

Retirement and tomato season

In 1991 Ross and Martha realized a dream they had worked toward for several years: they turned Seaside Farm over to their four children. Next thing they knew, they were staking 400 acres of tomatoes spread across 650 acres counting roads and ditches. By the early twenty-first century, production ranged from 600,000 boxes (15 million pounds) to 800,000 boxes (20 million pounds) a year. Market prices ranged from $3 to $10 a box. As one of the biggest tomato farms in South Carolina, Seaside found California's growers to be its biggest competitors.

"In order for us to do well, some other farmers have to have hard luck," Ross said. "As long as we can sell tomatoes west of the Mississippi, we do all right. If we're selling only up and down the East Coast, we can't make any money... You have to realize we are investing twenty times as much upfront per acre every year as we used to."

In retirement, Ross was doing a lot of fishing, especially in the Gulf stream. He and Martha also spent more time traveling, many times to Europe, once to China. The first time they visited Costa Rica, they were still taking care of the tomato farm, however. They went to scout what they thought would be their competition, Campbell Soup Co., planting three thousand acres of tomatoes there. Campbell Soup never set up such huge farms in Costa Rica, but Ross and Martha fell in love with the country and returned three more times, just for fun.

From about mid-March to mid-July, though, even after retirement, Ross and Martha continued to hang close to the tomato fields. While farming tomatoes on four hundred acres clearly was a year-round business, in early spring and early summer it was a sweaty, tense, intense, all-hands-on-deck business. Anxiety permeated the air along Seaside Road as everybody in the family worked day and night, watched the rain clouds and waited to learn what prices the market was bringing.

Early in the twenty-first century, from Ross's point of view, Gray and Mac and Lea and Caroline were doing a fine job, advancing a venture Gus Sanders, their great-grandfather, started almost a century earlier. By then, most of Beaufort County's other once-productive fields either lay dormant—and eyed for development—or already under new homes and shopping centers. The Sanders family's farm was rare—still farming and

farming big-time after all these years. Ross himself had given up only the day-to-day operation, not the knowledge or the passion for tomatoes and not the drive for the financial success of Seaside Farm. So he kept up the tradition he had started of wishing the tomato plants "good morning" early in the day and "goodnight" just before nightfall. It was his growing season thing.

At night sometimes he worried about what could happen to the farm on down the road. He thought of the possibility of losing the valuable fresh water from the wells as Savannah area industry pumped more and more from the Floridan aquifer. And he pondered over the potential loss of migrant labor.

For the most part, though, with Martha at his side, three of his children living just down the bank of Station Creek in a spiffy family compound and a fourth living in Frogmore Manor, his childhood home, he was contented. The fourth generation was in charge of the farm his grandfather started, and the fifth generation was coming along in his footsteps.

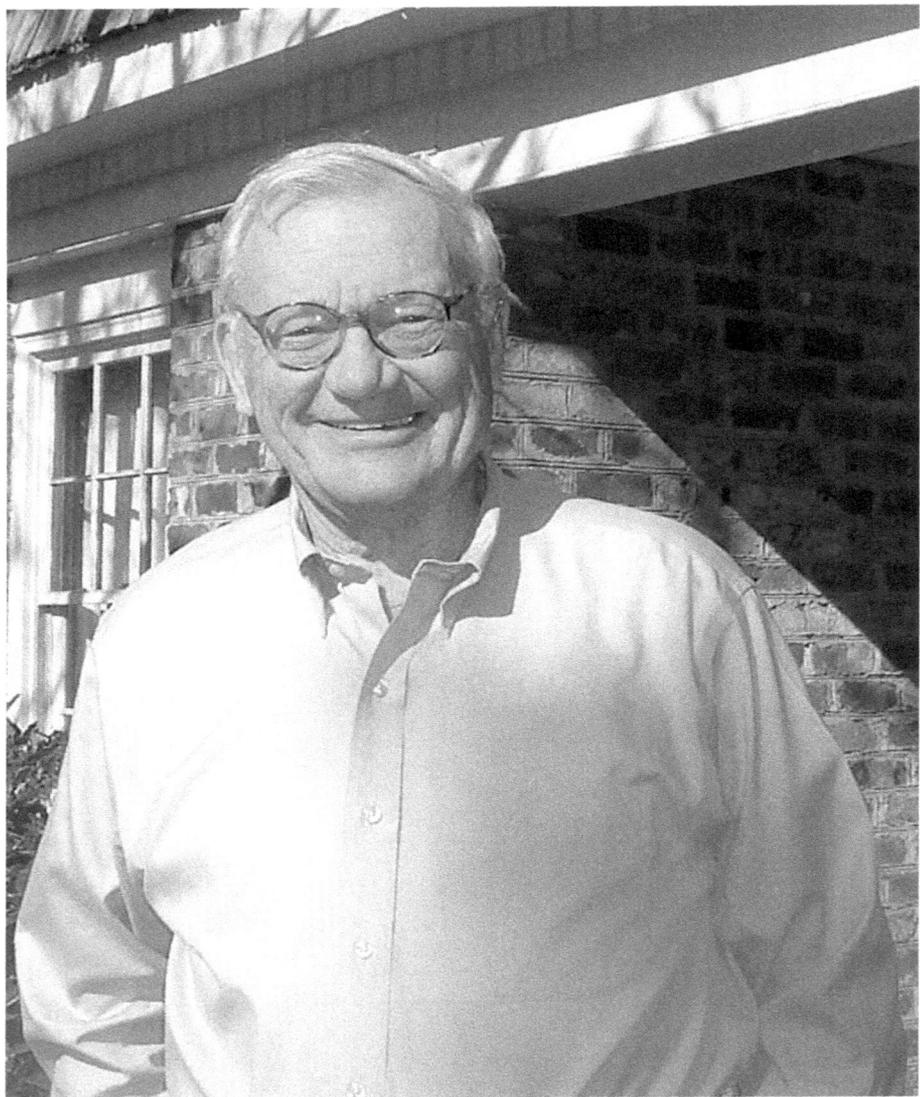

Brantley Harvey Jr.

PUSHING SOUTH CAROLINA ALONG

Brantley Harvey Jr.
born 1930

In the 1950s, the task of certifying the titles on property to expand the old navy station in the Seabrook area and build the Marine Corps Air Station became a big part of Brantley Jr.'s practice.

Even as a teenager, Brantley Harvey Jr. knew some things about his native South had to change. Signs posted over public drinking fountains identified those for whites and those for blacks. State law and Jim Crow customs required racial segregation almost everywhere. In most professional offices at the time, whites waited in one room, blacks in another. In contrast, Brantley noticed that his father, a lawyer and a state senator unafraid of going against the grain, served as a change agent by having an integrated waiting room. The clients, blacks and whites, got used to it.

When Brantley was a freshman at the University of South Carolina Law School in 1951, he took a similar stand. He and his colleagues in the class voted in a straw poll to close the law school at South Carolina State College (then all black) and have all law students, black and white, attend the law school of the University of South Carolina (then all white).

"I thought, why shouldn't whites and blacks go to law school together? We would practice in the same state and before the same judges. But, looking back, I guess we young law students were rather progressive for

our time and place. That was three years before the *Brown v. Board of Education* decision that eventually forced school integration."

By the time Brantley got interested in politics, he felt that, like his father, he ought to play a role in improving race relations. He had seen imaginative ploys used to reinforce segregation and strengthen whites' power.

In a crafty strategy historians have mostly ignored, for example, the South Carolina General Assembly in the 1940s deleted all references to party primary elections from the state code, the objective being to allow the Democratic Party, the only party with any power in the state, to become a private club. As a private club, it would run the primaries in June as a private activity. People had to apply for membership in the club. Here was the thinking: There was no active Republican Party in South Carolina at the time, so after the private Democratic Club ran the primaries, whoever won the primaries automatically would be elected in the General Election come November. No blacks need apply.

The Democrats thought they had a foolproof plan for the whites to stay in charge of state and local government. Justifiably, Brantley realized, the courts blocked their scheme.

In another such venture, legislators considered closing the state parks to avoid having to integrate them. Brantley was one of those who fought successfully to invite blacks to fish and camp and watch birds and otherwise enjoy the full range of park facilities, same as whites.

HERITAGE AN ASSET

From his vantage point early in the twenty-first century, standing on the porch of his circa 1814 home, Marshlands, Brantley realized that his deep Lowcountry roots had bolstered the strength it took for him to spend a lifetime advancing causes he held dear.

On his father's side of the family, his grandfather practiced medicine in Hampton. His grandmother, a Columbia College graduate, made history in 1930 by running for public office only ten years after the Nineteenth Amendment gave women the right to vote. Competing in a race of seven candidates, she came in fourth. "She never let us forget that she got more votes than three men," Brantley said, laughing. Grandmother Harvey also left Hampton for three years to earn a nursing degree in Savannah. In addition, she was an accomplished artist.

On his mother's side, his grandfather was a businessman in Hampton County's little town of Crocketville. After his grandmother was

widowed, she became a successful farm manager and poultry farmer. Sometimes Brantley would help her pack cases of eggs (forty-eight dozen to a case) to load on the train for shipment to Kinghorn's store on Bay Street in Beaufort.

Growing up in Beaufort as the only child of Brantley Harvey Sr. and Thelma Lightsey Harvey, young Brantley often rode the coal-fired steam train, called the Black and Dusty, to visit both sets of Hampton County grandparents. He felt he had the benefit of exposure to two different worlds. "By comparison to Hampton, Beaufort was lively, almost metropolitan, with a lot of activity on the docks, with the active military people and their dependents bringing a different perspective to us all," Brantley recalled.

PICKING TOMATOES, CRABBING COMMERCIALLY

As a boy, Brantley took on various, sweaty summer jobs; jobs that he later realized gave him a huge respect for those who earn their living with their hands and their backs. He packed tomatoes, picked cucumbers and once worked as a laborer in the steamiest business of summer, laying asphalt for the highway department. He worked as a laborer on construction of the U.S. Naval Hospital.

In the summer of 1945, Brantley and his friend Bill Marscher speculated that an old flat-bottomed boat, with its old but still running five-horsepower Johnson engine, could be put to use making money. Blue Channel, the seafood-packing house in Port Royal, furnished the two boys, as they furnished their other crabbers, with two hundred-yard cotton lines and the bacon, bull noses and pork rinds for bait. With anchors (old concrete blocks or a piece of a motor) and floats (usually a piece of discarded plastic) they set the baited lines on the bottoms of various creeks. After a time, they would pull in the lines slowly, deftly harvesting the crabs chewing on the tough meat, throwing them into fifty-five-gallon drums. They delivered their catch to the Blue Channel docks.

"As I recall," Brantley said, "we mostly had to go with the tide because the engine was so small. We had to buy the gasoline. We'd work the crab lines for several days and get paid at the end of the week. I believe we were the only white people crabbing commercially."

Except for the time spent working to make a little cash, Brantley spent the months June through August in khaki shorts, shirtless, playing about

the creeks and rivers. With his friends he'd lay a sleeping bag in the old
Coast Guard barracks on Fripp and Pritchards Islands and spend sunny
days surf fishing. With family and friends, he would take handmade
sailboats to races in Savannah and Rockville. "Nobody trailered boats back
then. We pulled the sailboats to the races with the *Owanee*, a houseboat
owned by Peoples Bank and used by almost anybody who needed it."

FAMILY AND LAW

Then came The Citadel. Then came a year of law school, during
which Brantley fell in love with a University of South Carolina
sophomore from Darlington, Helen Coggeshall. She was a smart,
independent-thinking young woman, in some ways like both of his
grandmothers. "We had a somewhat compressed romance," Brantley
recalled with a smile, "because I was about to go into the army." Soon
after they were married, they were stationed at Fort Bliss, Texas,
where Brantley served on the faculty of the anti-aircraft artillery
school for a couple of years. By the time he got back to Carolina to
finish his law degree, they already had one child, Eileen, and were
soon to have another. Helen finished getting her undergraduate
degree as a very pregnant student. Young Bill was born the week
Brantley graduated from law school.

Thanks to the military bases and to prosperous truck farming,
opportunity awaited Brantley and Helen in Beaufort County. Brantley
joined his father's law firm in 1955. Soon afterward, when a nationally
acclaimed criminal attorney came to town to represent a drill instructor
charged in the death of young Marines, Brantley said, "All of us young
lawyers went to court to watch the proceedings." The famous attorney
got to know Brantley and offered him the chance to practice law in
New York City. Thanks but no thanks, Brantley said. After that there
was never a doubt about where they would work and live and rear their
growing family.

In the 1930s, the task of acquiring all the rights of way necessary for
the U.S. Army Corps of Engineers to build the Intracoastal Waterway
from Charleston to Savannah had been a big part of Brantley Harvey Sr.'s
law practice. Twenty years later, in the 1950s, the task of certifying the
titles on property to expand the old navy station in the Seabrook area
and build the Marine Corps Air Station became a big part of Brantley

Jr.'s practice. It was steady work, interesting work, work that led young Brantley deep into Beaufort County's families and its property records. It also put Brantley into the thick of activity that would forever change the region.

POLITICS AND OTHER PUBLIC SERVICE

Then, following in the footsteps of his father, who served in the legislature from 1928 to 1952, Brantley decided after three years in the law firm to jump into politics himself. In those days, candidates for the House of Representatives ran countywide. As Brantley and Helen campaigned from Sheldon to Daufuskie, they made friends everywhere. As a member of the state House from 1958 to 1974, Brantley and his colleagues handled laws and policies and budgets at the state and also the county level. "This was before Home Rule," Brantley explained. "The county had an elected board of directors, but it had little authority. The legislative delegation in those days did everything from buying the county's bulldozers and draglines to dealing with appointments to statewide boards and with state legislation. The legislature also was in charge of the courts, both General Sessions [criminal] and Court of Common Pleas [civil]. Obviously, some of that needed to change."

Brantley became a leader in the historical movement to shift power in South Carolina away from the legislature and was re-elected every two years. By the time he left office, the General Assembly had made historical changes: It empowered county councils to run local affairs and empowered the state Supreme Court to run all the state's courts from top to bottom. On a local issue, the state had taken over the private Hilton Head Island Toll Bridge Authority. "That's how we reduced the toll to Hilton Head from $2.50 to $1.25 and then eventually removed it," Brantley said.

In 1974 Brantley ran for lieutenant governor as a Democrat and was elected at the same time Jim Edwards was elected governor as the first Republican in statewide office since Reconstruction. Brantley and Helen moved to Columbia and put their children in Columbia schools.

By 1978 Brantley believed he was ready to follow Governor Jim Edwards in the executive office. He competed with two others—Bryan Dorn and Dick Riley—for the Democratic nomination. "I didn't know it until later, but Bryan and Dick made the brilliant deal that whoever came out behind me in the primary would support the other one in the

runoff," Brantley said, raising his eyebrows. "When the primary votes were counted, I came in first and Dick, second; but for the runoff two weeks later, Bryan then kept his promise to Dick by swinging his voters to Dick, and that was the end of me."

Actually, as the advantage of perspective evolved, Brantley's years after elective politics became some of his most interesting and most productive.

Brantley served several years on the three state commissions and served for a while as chairman of the Beaufort County Democratic Party. He and Helen, who spent thirteen years as a University of South Carolina trustee, threw their political and financial support to the movement for USC-Beaufort to become a four-year institution with a new campus on the New River site near Sun City.

Brantley came to look critically at ethical issues not so obvious when he was in the middle of the political fray. "With today's widely held ethical standards, certain conflicts of interest clearly are inappropriate," he said. "I also saw, starting in 1978, the growing influence of big money on politics. I liked going about shaking hands and talking to voters to win them over, but later on the whole thing seemed to turn on the money and the media. That's a shame. It kept good people out of elected office."

Although Brantley's law practice and public service spanned more than fifty years, when asked in 2006 what in his life gave him the most happiness, the answer came quickly: "Helen and my children—five of them (Eileen, Bill, Helen, Margaret and Warren)—and my grandchildren. We have twenty-one grandchildren. They have been, and are still, a source of much joy to us."

And what advice would he offer in general, if asked? "I guess I'd say this: Don't make excuses. When things don't work out the way you'd hoped, figure out what went wrong if you can, go back and try again, or try something else."

And what advice would he give the state's political leaders, if he thought they might listen? "Raise the gasoline tax so we could build and fix the roads. I'm embarrassed at our roads compared to those in Georgia and North Carolina. Raise the cigarette tax. Make sure the schools are adequately funded, and restore appropriate money to higher education. In the past, South Carolina was a leader compared to the rest of the South. Now it's bringing up the rear. I'd like to urge some more forward thinking."

Forward thinking, it turns out, was something he'd been trying to do all his life—thinking, for instance, against prevailing custom, that blacks

and whites should sit together in the waiting room of his father's law office. Forward thinking showed up in his ambition as a young barefoot boy trying to make money crabbing. Forward thinking propelled him to work to reduce the power of the state legislature, when he was a member, in order to increase the county officials' power.

Brantley continued his law practice and his service on state boards even after surgery that left him walking with a cane and even after beginning to help Helen cope with a loss of vision. He couldn't imagine doing otherwise. History, he said, has put the community, the state and the region where we are today, but we need forward thinking to put us where we want to be tomorrow.

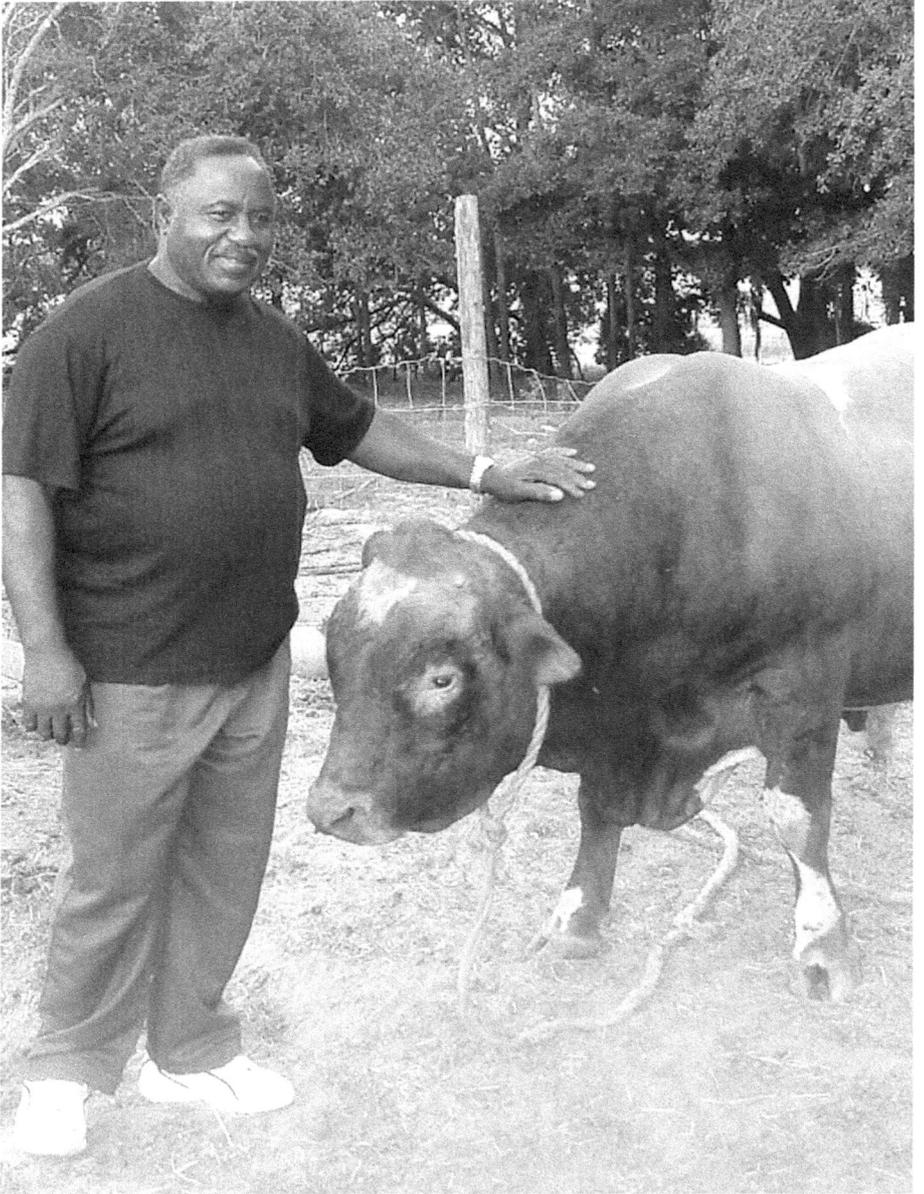

Paul Chisolm and "Bubba."

HEIRS' PROPERTY IN SHELDON

Paul Chisolm
born 1936

He joined the huge early twentieth-century migration of southern blacks to northern cities.

Paul Chisolm spent his childhood in a lively neighborhood in Beaufort County's Sheldon District, a community with four general stores, a shoemaker, a cotton gin and two railroad depots. The mostly black population was eight to ten times its size in the twenty-first century.

"In those days you would see fifty, sixty people walking down the (two-lane, sandy) road when you went from our home on Paige Point to the Sheldon post office. That's how people got where they wanted to go, whether to get the mail or see about somebody or to go to work or maybe go to the store. You would know 'most everybody you saw," Paul said. "Now you can ride all over Sheldon and not see much of anybody."

As far back as Paul could trace, his family's roots grew deep in the sandy soil on the edge of Huspah Creek in the Paige Point area of Sheldon. Both of Paul's parents, Ernestine Robinson and Paul Chisolm Sr., grew up in that area, living on heirs' property, which they passed down to their heirs when they died. Paul and dozens of kinfolk came to enjoy, and struggle with, joint ownership of forty-one acres of what eventually became valuable real estate.

Plenty of Chores

As other Sheldon families did in the '30s, '40s and '50s, Paul's parents enlisted their four sons and four daughters to work on their farm, to plant, cultivate and harvest tomatoes, cabbage, sweet potatoes, collards, turnip greens and kale. From the Sheldon Depot and the Coosaw Depot on the Port Royal-to-Yemassee railroad, they shipped their food crops by train. Paul could long recall the crates stenciled with addresses for New York merchants. They raised cotton as well, although by the time Paul, the second child, was a teenager, he had concluded that cotton farming was a waste of time and a waste of the little cash the family had.

"Thing was that you could make a few bales of cotton and get a few hundred dollars for it, but when you added all you had spent on the seeds and the fertilizer and thought about all the work it had taken to make that cotton, you had not made much money," Paul said. "I planted a vegetable crop on my own to show how some other things could pay off better than the cotton."

More than the crops demanded the children's help. Like the tide in the surrounding creeks and rivers, the rhythm of life was steady and predictable. Paul milked five cows many a morning before school. "I'd get home, and my mama would tell me, 'Go get some crab' or 'Go get some oyster.' With the crabs, all we used was a stick and bucket, but we got a lot of crabs back then. And the oysters were not the clusters of little old oysters people get now but singles, big as your hand. After supper every night, the wood for the cook stove had to be cut."

Late in the afternoon, the Chisolms' barnyard musicians mooed, oinked, clucked and quacked for attention. "We had chickens, geese, turkeys, guineas, ducks and everything, and they all had to be fed." In the fall everybody in the family took part in cutting, gathering and grinding the sugar cane to make syrup and in slaughtering, butchering and smoking hogs.

Sundays for the Chisolms meant Canaan Missionary Baptist Church: a place to see your friends, tell the news, get the news, a place to sing, a place to pray for better days. Tuesday nights meant movies in the two-room schoolhouse, always westerns, nothing else, just westerns. "That was all we had to look forward to," Paul said. Except for paying taxes in Beaufort a few miles away from their home, the Sheldon folk of Paul's childhood had little reason and almost no means to travel anywhere.

OFF TO NEW YORK

Young, restless Paul Chisolm found himself yearning to see something bigger, find some excitement, face some bigger challenges than he could find in Sheldon. He knew there must be, somewhere, more going on. Lucky for him, he was only fourteen when a man who traveled the country harvesting potatoes met him at a ball field in Sheldon and offered him a summer job on Long Island. "I was a husky boy, about as big then as I am now, round 'bout 180 pounds," he said, laughing. "He thought I would be a good worker. It was so hard for me to ask my parents to let me go. Then when I asked them, they sent me back and forth from one to the other before I could get an answer from them. Finally they said OK, though, so I spent several weeks up on Long Island. Even though I was doing farm work, it was wonderful exposure."

Confidence and courage came out of that "exposure." Shortly after graduating from Beaufort County's Shanklin High School, Paul benefited from further "exposure." Paul joined the U.S. Army, signed up for jump school and served for almost three years as a paratrooper with a year in Korea and a year in Hawaii. After his discharge, he looked hard at the reality of home in Sheldon: "There were no jobs. I had to go somewhere to work." After one month he joined the huge early twentieth-century migration of southern blacks to northern cities. He headed to New York to live with a cousin and look for a job.

Paul worked for Western Union for three years, drove a taxi for two years and then began driving a bus for the New York City Transit Authority, where he had his route, had his regular passengers and his regular wages. He enjoyed movies and plays, married and reared four children. Paul felt successful in that fast-paced, multi-ethnic environment.

During the more than two decades he lived in New York, though, Paul often drove home to Sheldon on long weekends to keep in touch with the land and the people he had loved from birth. He liked the pace and the smells of the Lowcountry. He liked hearing the cows moo. He always had in mind that he would retire when he was still relatively young, with a pension, and move back to Sheldon and "live the good life" in the place of his ancestors. After driving a city bus "twenty years, five months and three days," he drove a charter bus for five years more and then finally retired a second time.

In 1990, Paul and his second wife, Dorothy, settled in the Chisolm family compound on Paige Point, on the forty-one acres comprising the "heirs'

property," land owned by more and more relatives as family members died and their heirs inherited interest in it.

CONCERN ABOUT DEVELOPMENT

Alert to the pressure on coastal land and landowners, Paul the bus driver, now Paul the retiree became Paul the keen observer of Beaufort County Council, especially interested in its land-use policies and taxes. Paul Chisolm watched as County Council crafted a development agreement on five thousand acres for Sun City Hilton Head and worried for Bluffton. "I knew Bluffton was going to explode with growth and then the people who lived there all along were going to have a hard time paying the taxes. Besides that, they would face congested roads and crowded schools. All that has come true," he said.

Like others who use the phrase "economic development" frequently, Paul occasionally dreamed about Sheldon as a place where residents might not have to leave to make a living. Unlike many others, he objected to others' visions of Sheldon as a place filled with developer-designed subdivisions attracting people of means who happen to have fallen in love with live oaks and salt marsh. "What kind of jobs are coming with subdivisions here? They have nothing to offer but jobs that pay so little people can't live on the money. And then what kind of property values come with subdivisions? Such high values and high taxes that people who lived here all their lives, and whose parents and grandparents lived here, can't afford to stay."

Although Paul would have been happy to see many of his Sheldon area cousins, aunts, uncles and neighbors in better financial situations, he could never see the kind of residential and commercial development springing up all over most of the rest of Beaufort County as a means of helping Sheldon.

Early in the twenty-first century, Paul was, indeed, living well. Paul kept three cows, two bulls and a horse in his backyard overlooking the marshes of Huspah Creek. He drove a school bus for special-needs children. He had a host of family members around and a host of friends, many familiar from his boyhood days. He was in touch often with local political leaders.

By then, Paul was able to reflect on changes he had experienced. As a black child of the rural South in the Jim Crow era, he had met plenty of racial prejudice in his time. "You couldn't go here, couldn't go there. Even in the military, the official policy was racial equality, same for whites and 'coloreds' as they called us then, but it wasn't really so. Yes, there

has been a lot of progress in racial relations, but some of the relations are still pretty superficial. The disadvantages to black people continue." Bitterness, though, was not a burden Paul chose to tote with him. "What I have tried to do about the racial disparities, mostly, is to bear with them until I could get myself in a position to do something about them," he said, smiling. "My exposure to various ways of life, other places, at a young age, helped me."

Along with Paul, every one of his siblings—three brothers and four sisters—made their way north to New York and Chicago and Detroit after growing up in Sheldon. His parents raised two additional children after raising eight of their own. Of the eight who left Sheldon, all but one eventually returned to the place they were born, to the land they owned together. As they settled into the neighborhood home of their childhood, the property grew increasingly valuable as potential waterfront development property on South Carolina's fast-growing coast. Paul especially was determined to try to hang onto their heirs' property, forty-one acres handed down through the generations, handed down with a wealth of family memories.

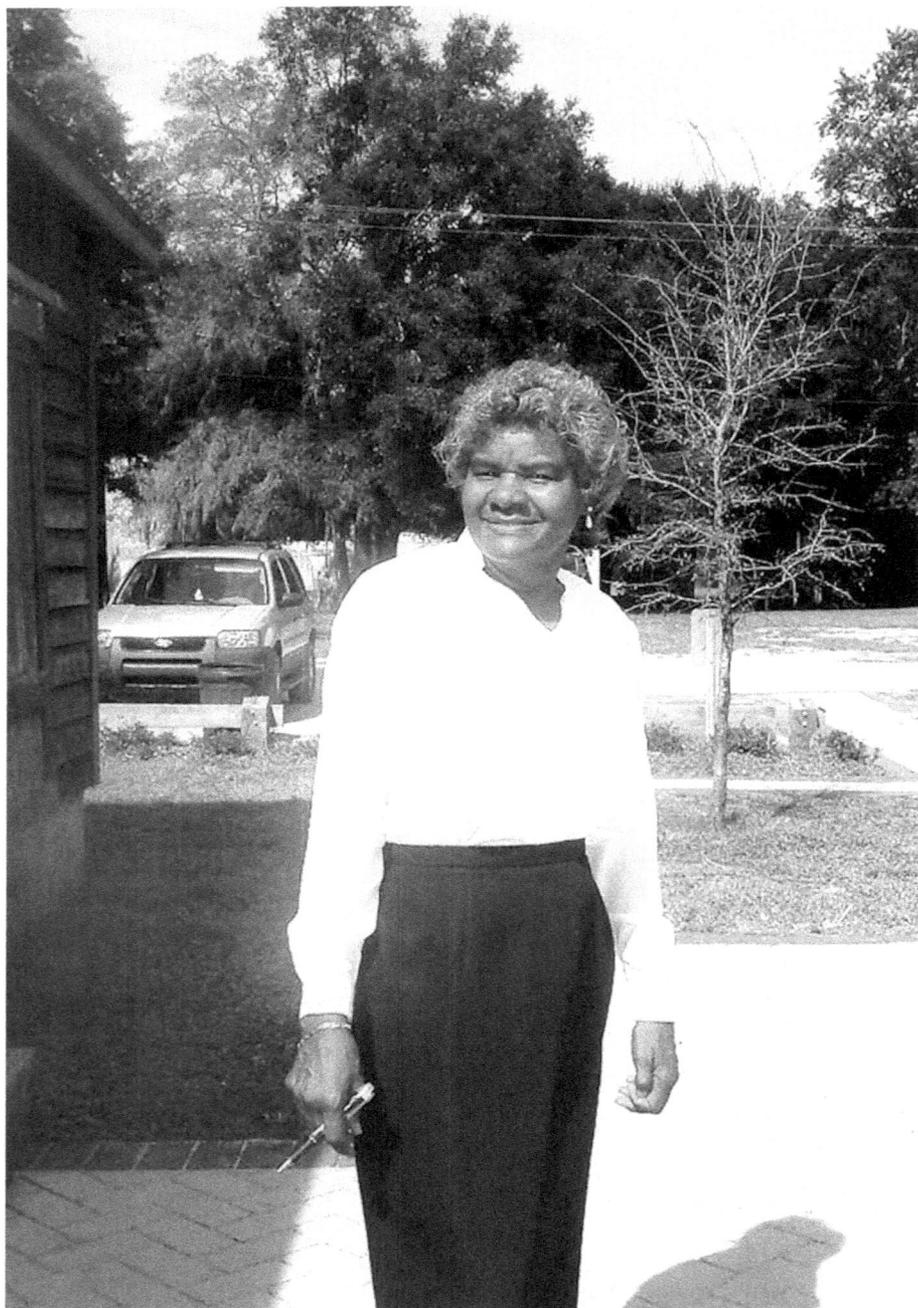

Gardenia White.

A SOUTHERN LADY
WITH CLASS

Gardenia Simmons White
born 1936

The girls could have their hair "pressed" for stage events at school or church, but as soon as the events were over, their hair had to be braided again.

Gardenia White carried an aura as distinctive as the flower that shared her name. Credit for the person she became, she said, went to her father, to Penn School and to the culture of her beloved St. Helena Island.

Her ancestors were slaves, her grandparents and parents descendants of slaves. "Captain" Richard Middleton—made famous by a photograph of him standing tall and erect in the mud with his bateau, oar, bucket and shrimp net at the edge of a creek on St. Helena Island—was Gardenia's grandfather on her mother's side. Families on both sides were large, birth control nowhere on the horizon. Gardenia's mother gave birth to thirteen children. She had two babies out of wedlock before marrying Gardenia's father. Then she had five more babies, of whom one died young. Then she left Gardenia's father and his four children—three girls and one boy— to seek her fortune in New York City. In New York, Gardenia's mother married a second time and gave birth to another six children.

More than half a century later, Gardenia and her siblings and half-siblings were all friends with one another. Many of those born in New York eventually settled on St. Helena. In that family, as on St. Helena generally, family was family and so was always a part of one's life.

Left as youngsters in the care of their father, Gardenia and her sisters, Evelena and Ethel, and her brother, Benjamin, had the unusual good fortune to grow up in a South Carolina Lowcountry household whose income was not seasonal, as in oyster picking and shucking, and whose income did not depend on how the weather treated the crops of cotton, corn and sweet potatoes. Frank Brown worked on Parris Island, catching the workers' vehicle pool to get there five days a week, picking up a regular paycheck. On weekends he tended his vegetable garden with his mule or his ox. He kept chickens and a cow. He did not allow his daughters to work in the fields.

Frank Brown's mission in life was to rear his children as a single parent in a manner that led them to upright living and self-sufficiency. For them, that meant going to Penn School with near-perfect attendance records, studying, scrubbing the floors at home, sweeping the yard. That meant reading was considered entertainment. That meant going to Brick Baptist Church not only on Sundays but also on whatever other day or night of the week there were programs for children. That meant not riding the bus to basketball games at night but being picked up and delivered to the door by car; Frank knew the risks of on-the-bus smooching among teens and he would have none of it among his daughters.

As for braiding hair, Frank didn't know how to do that so he took his daughters to neighbors for the braiding until they were able to do it themselves. "When we got cornrows," Gardenia remembered, "they would last a week." According to Frank's rules, the girls could have their hair "pressed" for stage events at school or church, but as soon as the events were over, their hair had to be braided again.

EARNING AND LEARNING AT PENN SCHOOL

The children earned their Penn School tuition by working in the summer in Penn's famous cannery, a hot, bustling operation in a building on campus. Adults supervised and did much of the work, but the young girls and boys learned to peel the scalded tomatoes and peaches and so contributed immensely to the process. Gardenia could remember fifty years later the smells and the scenes: the cooking vats, the cans, the Mason jars, the cut okra, the string beans. The vegetables thus preserved were served in the dining hall year-round.

Canning was one of numerous activities that served the dual purpose of making Penn self-sufficient while teaching the students varied, practical skills. From the time of its founding in 1865, Penn was an industrial and agricultural school as well as a "normal" (academic) school. Along with

reading, writing and arithmetic, the students were taught to use their hands, taught to use tools and equipment, taught to think independently and taught to think of themselves as responsible for themselves.

"At the time we didn't realize what all we were getting," Gardenia said, smiling. "It was only later," she laughed, "that we could see the benefits."

Before 1948, for the blacks on St. Helena and on Hilton Head Island and in many other communities, the state and county provided public education through seventh grade only. Unless older students' parents could afford private school, or unless the students could earn their tuition as many did at Penn, there was no option for education for blacks beyond the age of about twelve or thirteen.

Slowly, pressure built from the growing civil rights movement, and, finally, in 1948, the Penn School that had operated for more than eighty years closed and Beaufort County took over the facilities to open Penn High School as a public school. Gardenia graduated from Penn High in 1952. Within a couple of years, Beaufort County opened St. Helena High School for blacks. Once that happened, local leaders created Penn Community Services on the campus to focus on community health, library services, economic development, community organization and recreation. The mission expanded later to include service as a conference center, made famous for civil rights leadership training in the 1960s, more recently for other kinds of conferences. Early in the twenty-first century the organization was Penn Center, Inc., a nonprofit organization.

In the mid-1950s, even for a bright, disciplined high school graduate, prospects were dim in the South Carolina Lowcountry. "There was nothing, really, for me to do after high school," Gardenia said. Gardenia had only heard about New York City and read a little about it, but the directors of the new Penn Community Services, Inc. drove her to New York to move in with a cousin. There she saw crowds bigger than she had ever imagined, people of all races and ethnic mixes. There in late afternoons she heard the roar of the subway trains instead of the coo of St. Helena's mourning doves. There she found her way. She found—and made—opportunity. After short stints working in a restaurant and as a nurses' aide, soon she was a proud student nurse at Manhattan State Hospital School of Nursing.

A NURSING CAREER

From there, Gardenia parlayed her three-year nursing diploma into a bachelor's degree and a master's degree and a thirty-three-year career at

a Veterans' Administration hospital in Manhattan. During that time, she married, had three children, divorced and spent several years as a single parent working day and night to hold everything together. She wed a second time and enjoyed a thirty-year marriage.

In 1992, when Gardenia and her second husband retired, they moved to St. Helena, where she was happily home again at last. Within two years, she had lost her husband and so was on her own once more. Then she married Nat White of Hilton Head Island, a fellow Penn School alumnus, and had seven and a half good years with Nat until he died in 2004.

The upshot was that, at the age of seventy, Gardenia was once again a single woman, and her skills and judgment were much in demand. After returning to the Lowcountry, Gardenia worked five years for Beaufort-Jasper Comprehensive Health services and five years for Volunteers in Medicine before retiring a third time. In 2005, she was deep into a couple of new ventures.

For a time, Gardenia took on the job of co-manager of Penn Community Center's York W. Bailey Museum, a repository of artifacts and programs devoted to preserving the Gullah heritage. "We are not curators by profession, but we are keeping this museum going," she said. In addition, working with twenty-nine other retired nurses in the community, Gardenia also was president of the Gullah Church Nurses Association, a repository of talent and knowledge devoted to teaching health care skills through the local black churches. "We get into whatever will help people take better care of themselves," she said. "We relate to people as individuals. You cannot ignore a person's culture when you want to educate people."

By the eighth decade of Gardenia's life, she had shed her share of tears. She and her siblings had been essentially abandoned by their mother. She divorced after twelve years in the first marriage. During the most demanding period of her life, working, going to school and taking care of her children as a single parent, she forced herself to make it on only a few hours of sleep every twenty-four hours. Her husband of thirty years died after two years of retirement. Her third husband also died too soon. There had been no life of ease for Gardenia.

Joy, though, was what Gardenia exhibited as she took care of business important to her and to the St. Helena Island community in the twenty-first century. A gardener might say she blossomed because she had deep, strong roots.

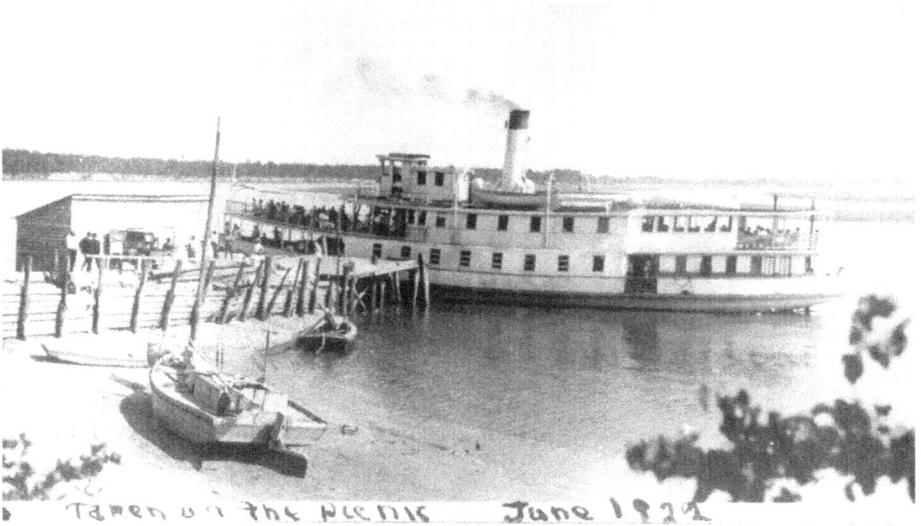

Steamboat Clivedon. *Courtesy of Elaine Sutcliffe.*

Visit us at
www.historypress.net

www.ingramcontent.com/pod-product-compliance
Lightning Source LLC
Chambersburg PA
CBHW060811100426
42813CB00004B/1036